THE F1 WORLD CHAMPIONSHIP AT THE BRITISH GRAND PRIX

70 YEARS IN PHOTOGRAPHS

The History Press

First published 2020

The History Press
97 St George's Place,
Cheltenham, Gloucestershire GL50 3QB
www.thehistorypress.co.uk

British Library Cataloguing in Publication Data.
A catalogue record for this book is available from the British Library.

ISBN 978 0 7509 9438 5

Typesetting and origination by The History Press
Printed in Turkey by Imak

INTRODUCTION

The British Grand Prix race has an impressively long history that stretches back to 1926, when it was first held on the Brooklands circuit. It became an annual fixture by 1948 and in 1950 it first ran as an official part of the FIA World Championship calendar.

The F1 World Championship at the British Grand Prix looks back over the immense changes to occur over that seventy-year World Championship period, beginning with the hectic, heady and exciting days of the early championships, when such illustrious names as Juan Manuel Fangio and Stirling Moss battled to break new records. Over the years, unsafe and unwieldy cars driven by incredibly brave and highly skilled drivers have evolved into the sleek, superfast and comparatively ultra-safe beasts of today, whose drivers, of course, remain equally as skilled. There have been many dramas, crashes and thrilling moments along the way at iconic tracks such as Aintree, Brands Hatch and Silverstone: the great rivalry between Lauda and Hunt; memorable names including Senna, Prost, Schumacher, Mansell, Coulthard and Hill; and the modern-day achievements of Lewis Hamilton.

The Mirrorpix Group's associated press photographers have been present at many pivotal moments across the seventy years of British Formula One, and their dramatic and evocative images chart the inexorable progression of the ultimate motorsport.

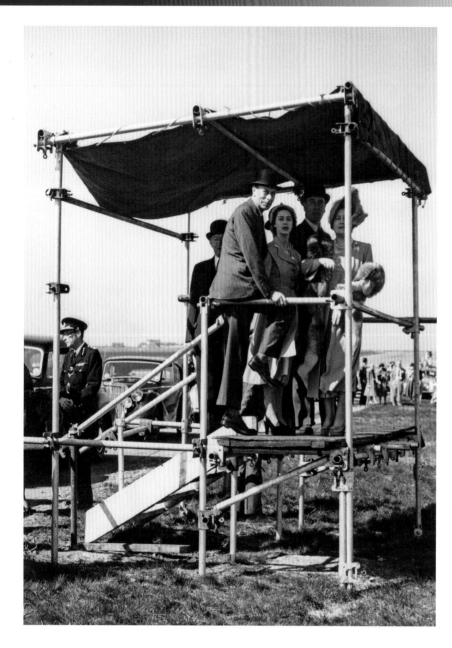

◄ The Royal Family attend the fifth British Grand Prix at Silverstone, Northamptonshire, which is also the inaugural World Championship of Drivers Formula One race. Standing on the viewing platform are King George VI, Queen Elizabeth and Princess Margaret, Saturday 13 May 1950.

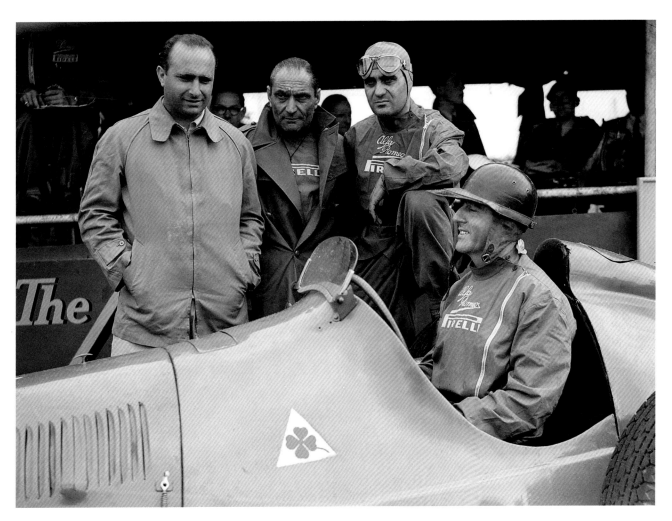

⌃ Juan Fangio is seen here with Felice Bonetto, Consalvo Sanesi and Giuseppe 'Nino' Farina (in car) during the final practice at Silverstone for RAZ Grand Prix, July 1951.

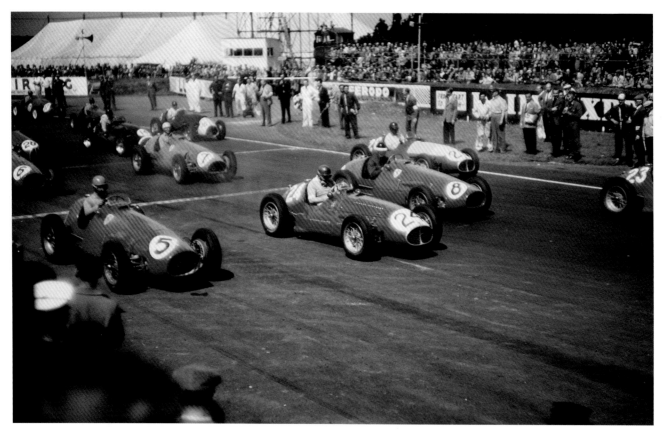

▲ The British Grand Prix held at Silverstone, 18 July 1953.

The race was run to Formula Two rules, rather than the Formula One regulations normally used. The start of the race shows the three Ferrari 500 cars of Alberto Ascari (5), Mike Hawthorn (8) and Luigi Villoresi (7). In the centre of picture is Argentine driver José Froilán González in a Maserati.

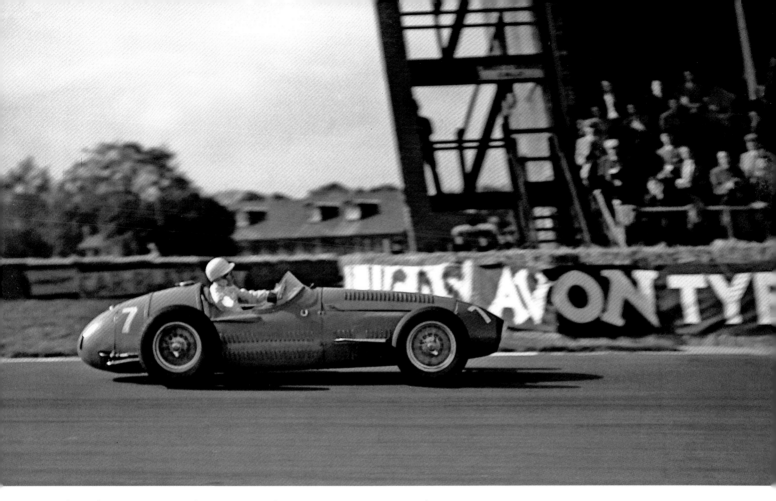

▲ Stirling Moss winning the Aintree Trophy Race in a Masserati, 6 October 1954.

In the 1950s, the name 'Stirling Moss' was synonymous with motor racing in Britain. What Stanley Matthews was to football, Stirling Moss was to motor racing.

However, despite his popularity and wealth of talent, Moss never won the World Driver's Championship. Some have claimed that this was because he loved motor racing too much: he wanted to race too many types of cars, never concentrating solely on Grand Prix racing.

His first Grand Prix was in Switzerland in 1951. He was teammate to Fangio – possibly the greatest ever Grand Prix driver – first with Maserati, then Mercedes, then again Maserati. Over these three years Fangio won the Championship three times, with Moss as runner up on each occasion. Moss came close on one more occasion, but again came second, this time to the British driver Mike Hawthorn by one point. His career ended on Easter Monday 1962 after a high speed crash at Goodwood and his famous 'lucky No. 7' car was not seen in a Formula One Grand Prix again, although he did return to saloon car racing.

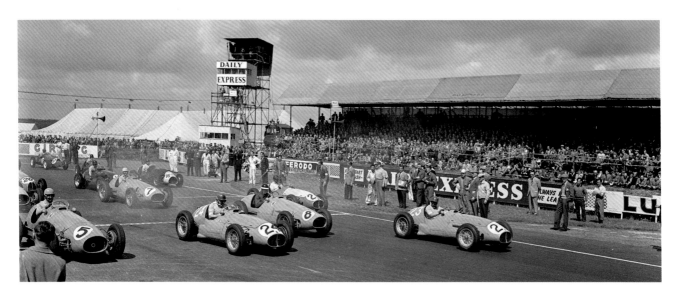

▲ The start of the 1954 British Grand Prix at Silverstone.

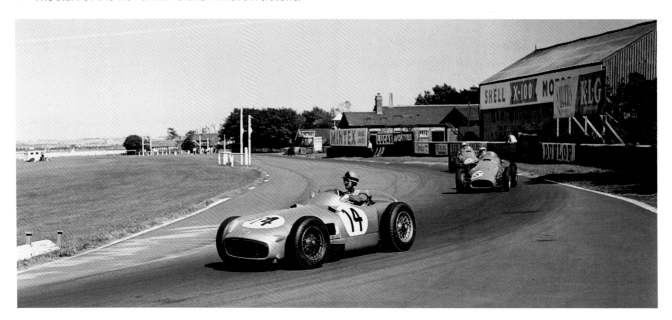

▲ Karl Kling leads Roberto Mieres in the British Grand Prix at Aintree, Liverpool, 1955.

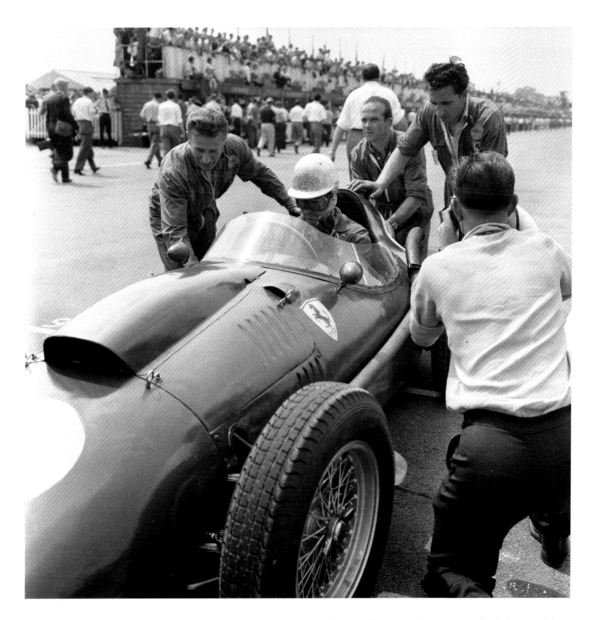

▲ Peter Collins sits in his Ferrari Dino 246 at the 1958 British Grand Prix at Silverstone, which he would go on to win.

1960s

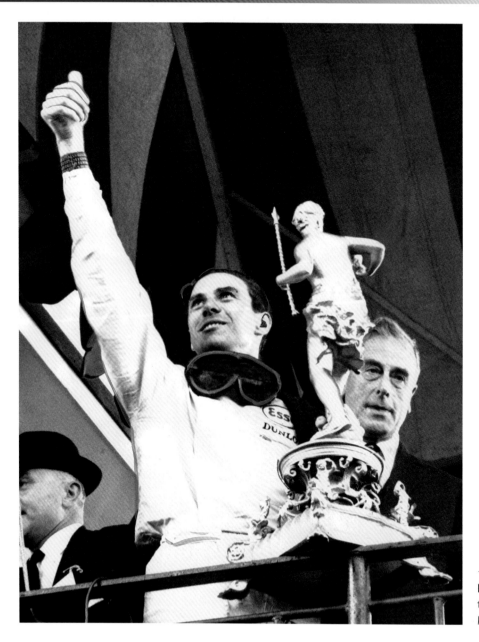

◀ Jim Clark waves to the Brands Hatch crowd as he holds the trophy presented to him by Earl Mountbatten, 11 July 1964.

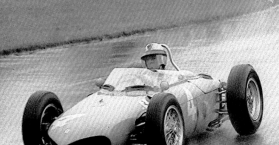
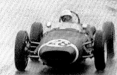

▲ Eventual British Grand Prix winner Wolfgang von Trips in his Ferrari Dino 156 (4) leading Stirling Moss at Aintree's Tatts Corner, 13 July 1961.

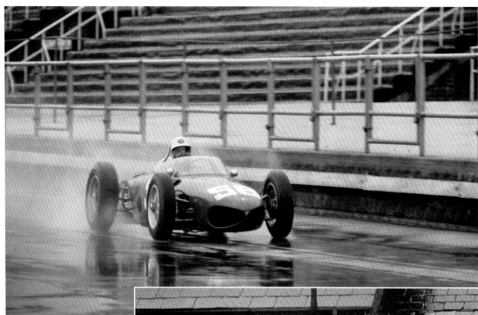

◄ Giancarlo Baghetti in action in his Ferrari Dino 156 at the British Grand Prix Formula One at Aintree, 15 July 1961.

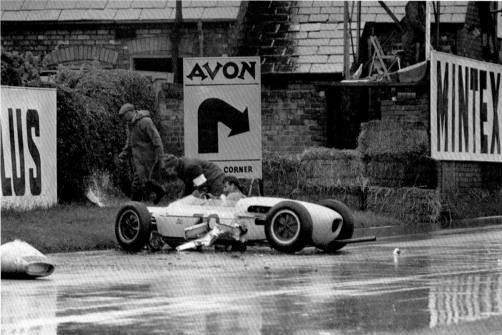

➤ A crash at Aintree, 15 July 1961.

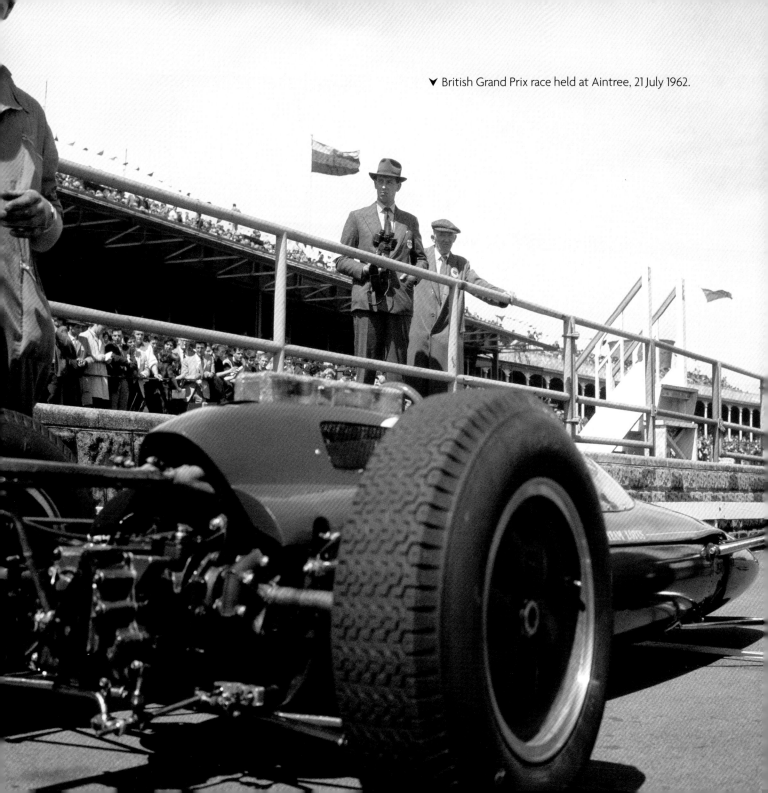
▼ British Grand Prix race held at Aintree, 21 July 1962.

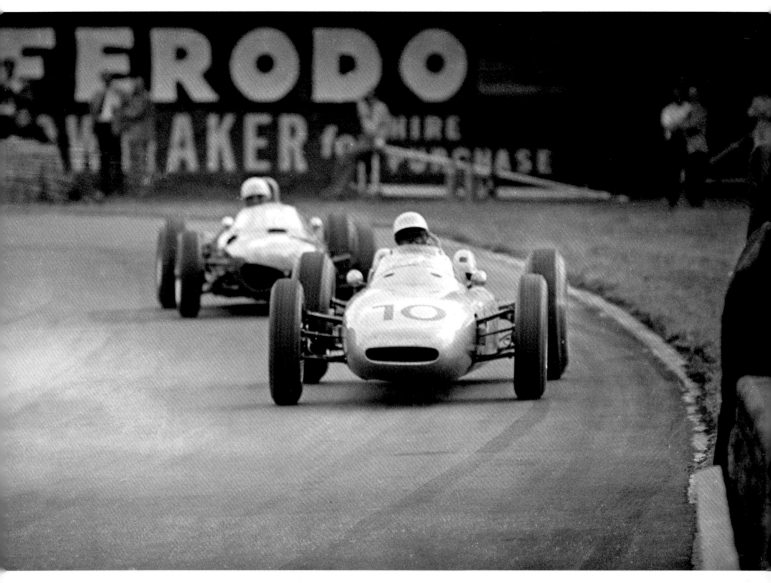

⌃ Jo Bonnier in his Porsche 804 at Aintree, 21 July 1962.

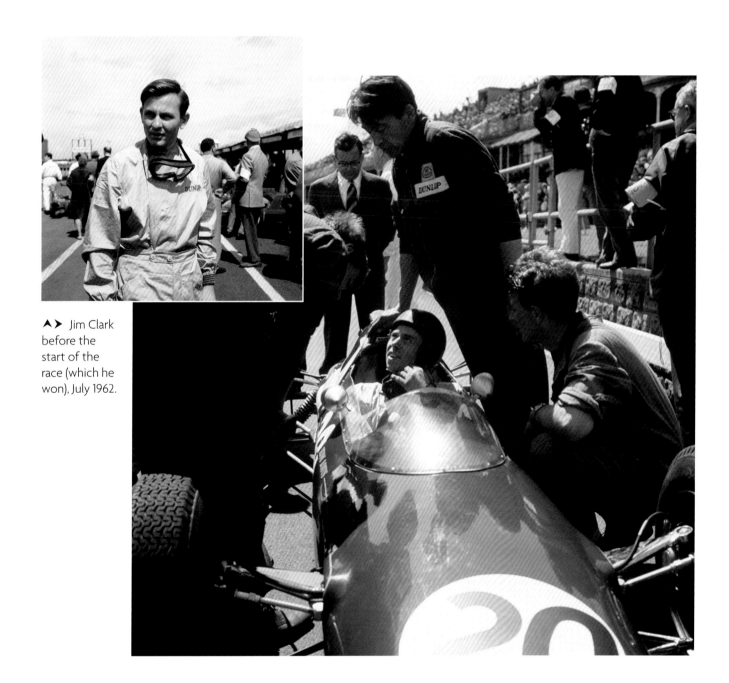

▲➤ Jim Clark before the start of the race (which he won), July 1962.

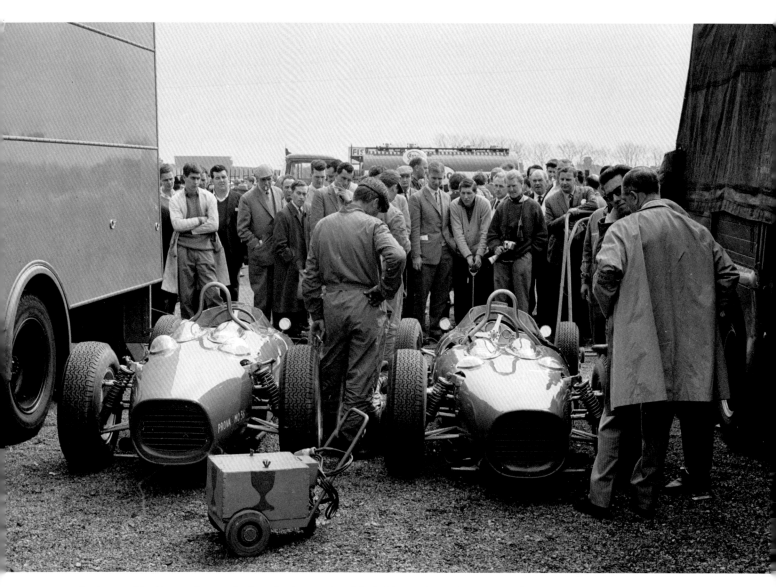

▲ A crowd looking at the cars before the International Daily Mirror Cup at Aintree, April 1963.

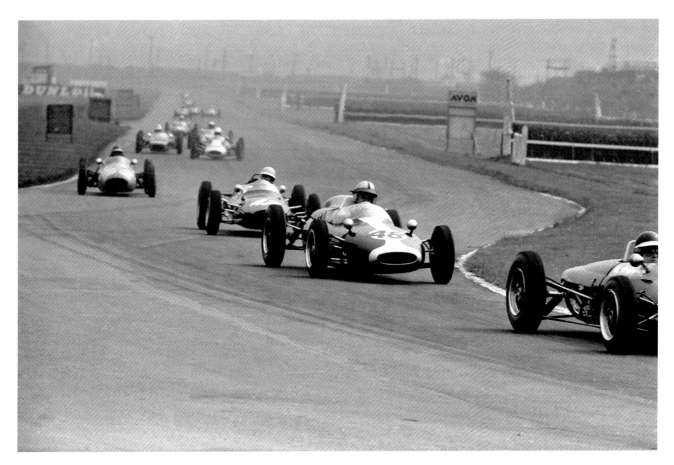

∧ Cars in action at the International Daily Mirror Cup at Aintree, April 1963.

▲ Roy Salvadori takes the chequered flag to win the race in his Cooper Monaco Climax, Aintree, April 1963.

➤ John Surtees of Ferrari gets a push from the mechanics on the way to the track at the British Grand Prix Silverstone, July 1963.

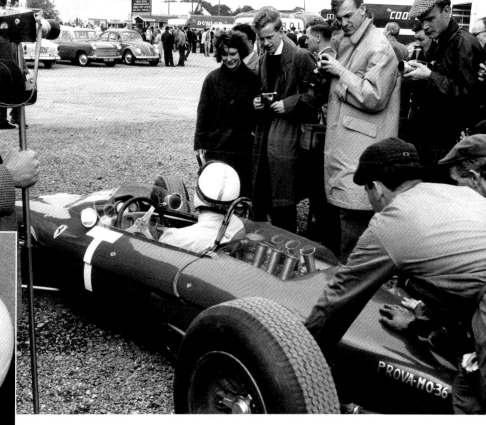

◄ Bruce McLaren ready to go as he leaves the paddock for the grid at Silverstone, 19 July 1963.

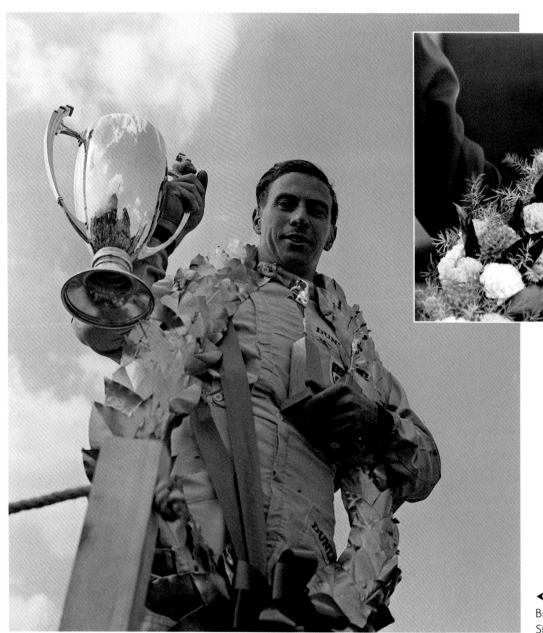

◄ Jim Clark wins the British Grand Prix at Silverstone, 1963.

◀ Jim Clark, driver for Lotus-Climax, pictured celebrating after winning the British Grand Prix at Brands Hatch, Kent, 11 July 1964.

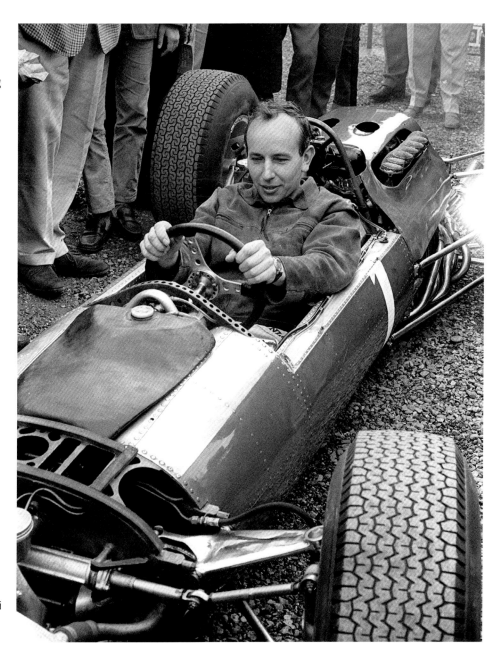

➤ John Surtees sits in his Ferrari number 1 car. British Grand Prix, Silverstone, July 1965.

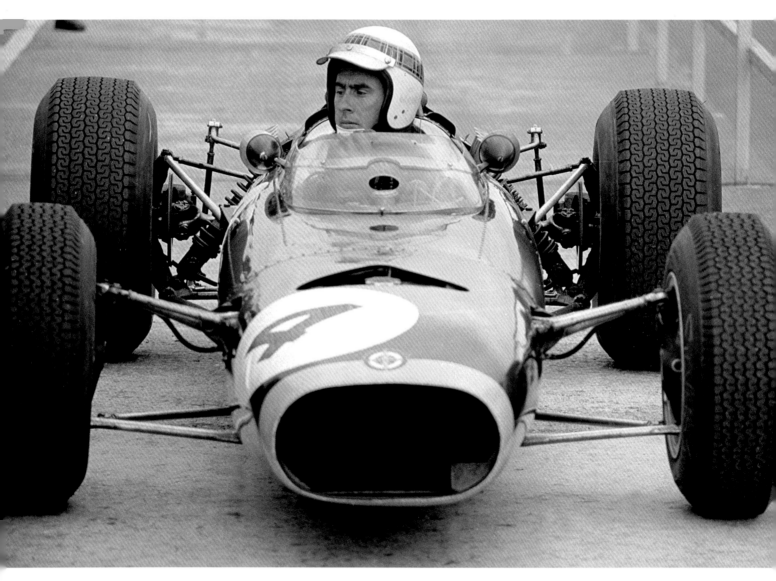

▲ Jackie Stewart in his Lotus at the Silverstone practice day, July 1965.

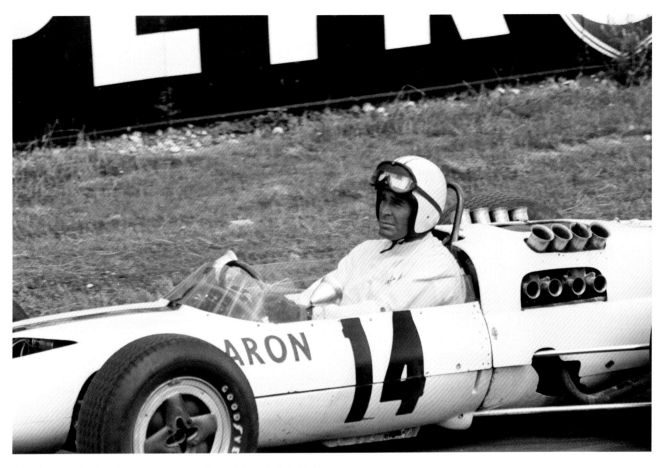

∧ Filming of MGN film *Grand Prix* at Brands Hatch, July 1966.

In *Grand Prix*, actor James Garner starred as American Grand Prix driver Pete Aron, who is fired by his Jordan-BRM racing team and begins to drive for the Japanese Yamura team. During filming, Garner had to drive his racing car (no stunt man) for half a mile around the Brands Hatch circuit while on fire, with firemen on standby.

 Garner stopped just after the finishing line and leapt from the cockpit as flames engulfed the car. He was insured for £1 million during the making of the film.

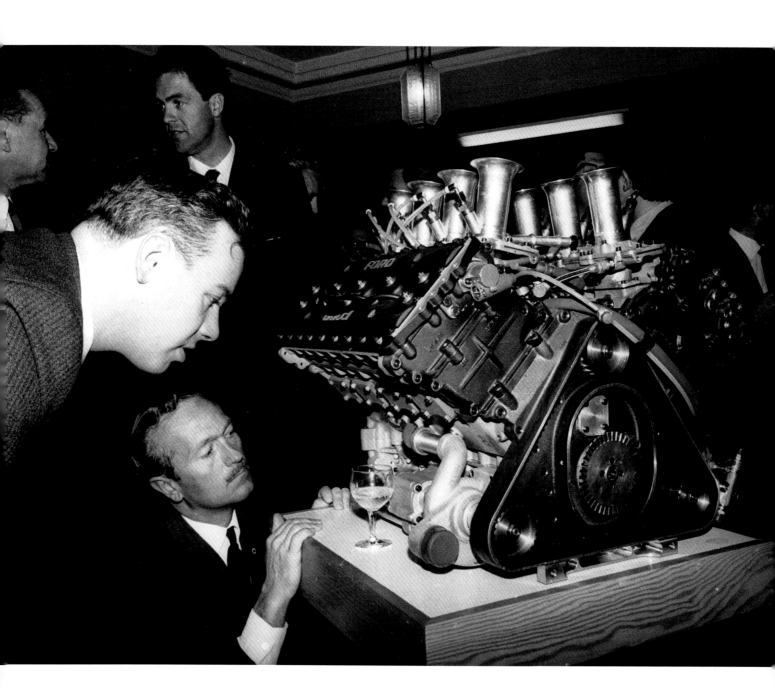

◄ The new Formula One Ford Engine being looked at by its designer Keith Duckworth and Lotus founder Colin Chapman, April 1967.

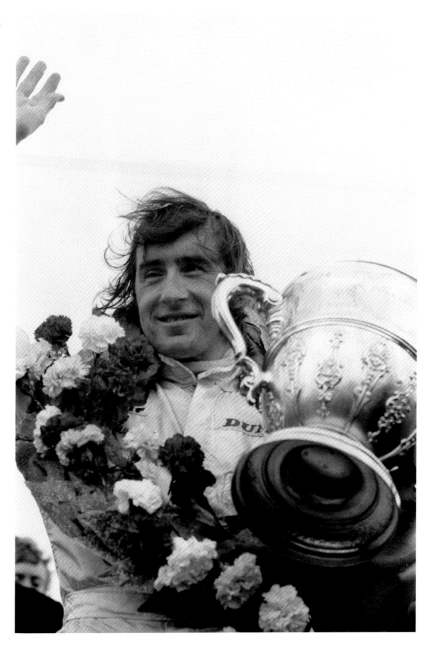

➤ Jackie Stewart, World Champion, pictured after winning the British Grand Prix, 19 July 1969.

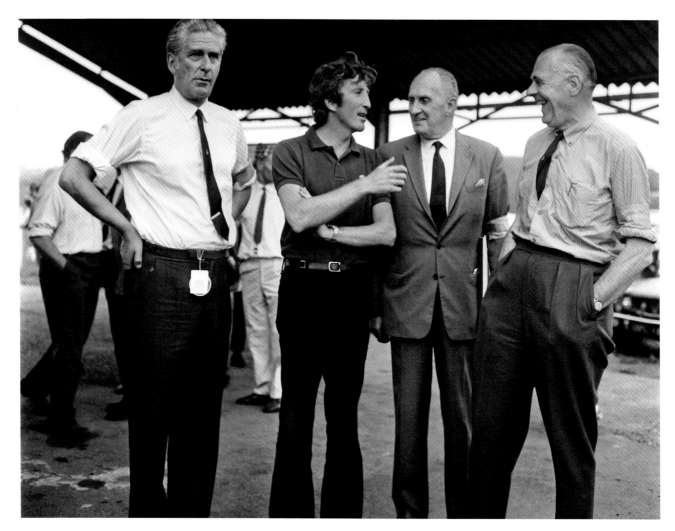

⌃ Jochen Rindt (second left) has a friendly chat with the official stewards after they overruled the objection to his winning the British Grand Prix because of the incorrect height of aerofoil on his Lotus Ford. Brands Hatch, July 1970.

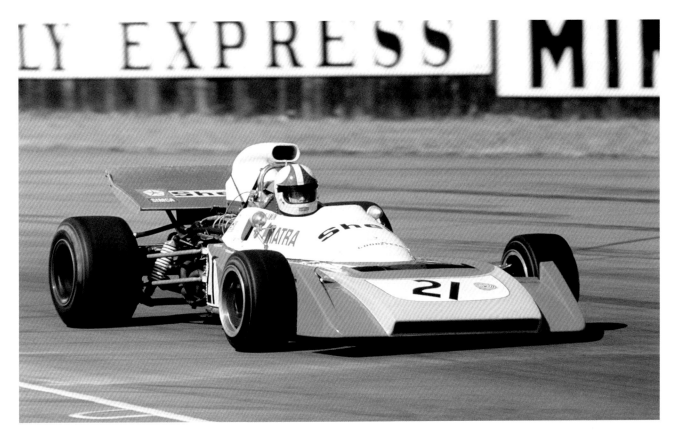

∧ Chris Amon in his Matra at Siverstone, July 1971.

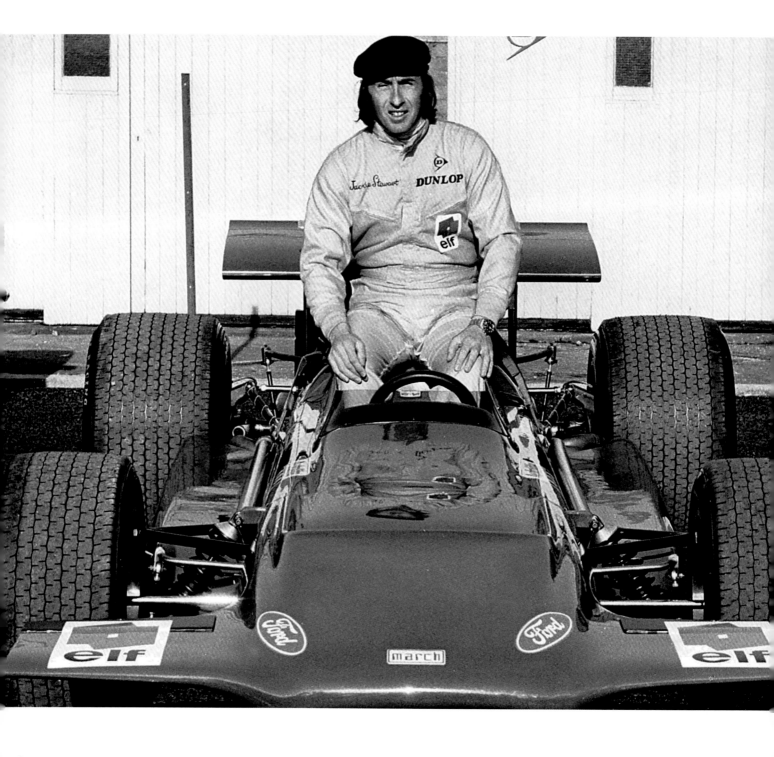

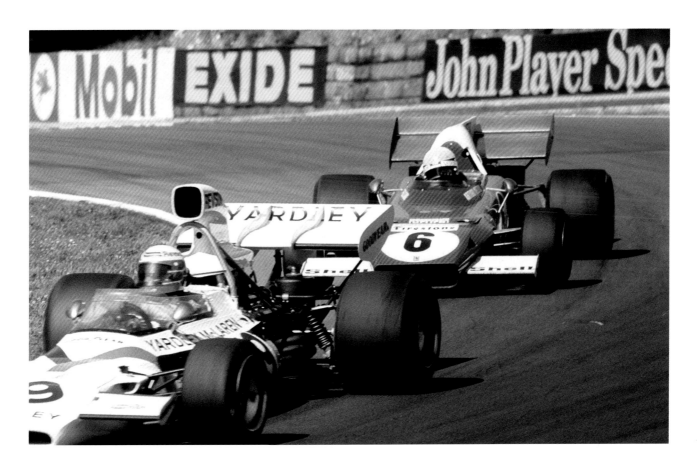

▲ Peter Revson in the McLaren number 9 car leading Arturo Merzario in Ferrari 312 B number 6 car at Brands Hatch, July 1972.

◄ Jackie Stewart sits on a Formula One racing car in the pits, *c.* 1972.

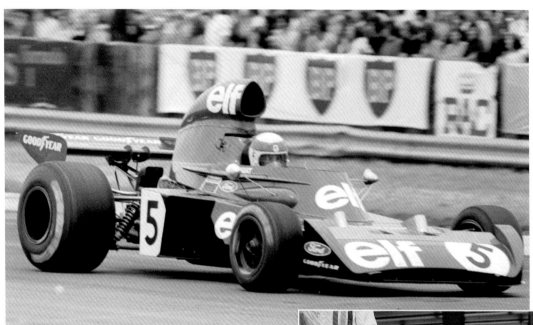

▲ Jackie Stewart competing in the 1973 British Grand Prix in his Tyrell Cosworth 006.

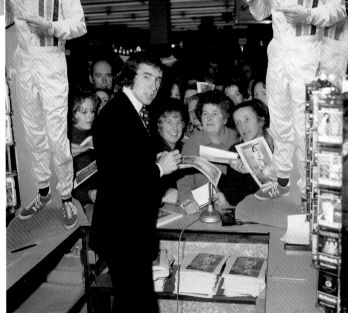

➤ Jackie Stewart signing autographs, 1973.

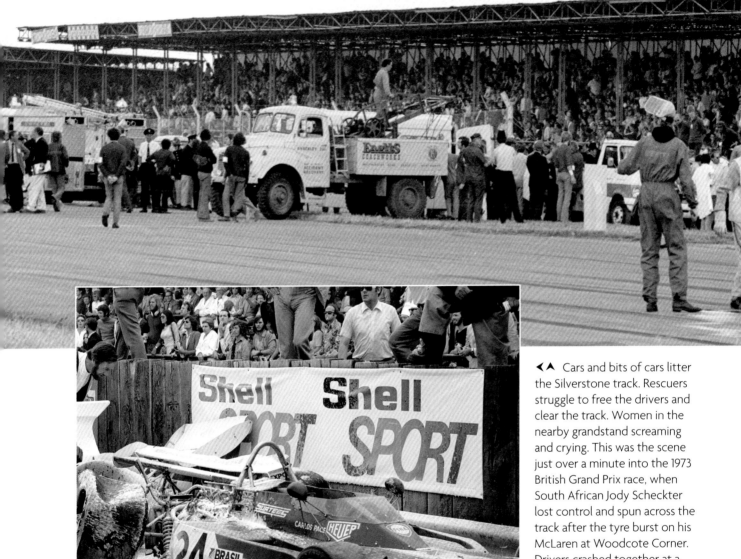

◄▲ Cars and bits of cars litter the Silverstone track. Rescuers struggle to free the drivers and clear the track. Women in the nearby grandstand screaming and crying. This was the scene just over a minute into the 1973 British Grand Prix race, when South African Jody Scheckter lost control and spun across the track after the tyre burst on his McLaren at Woodcote Corner. Drivers crashed together at a combined speed of 170mph, but miraculously only one driver was hurt, suffering a broken ankle.

▲ 'David Frost, TV personality, is to drive in the first motor race at Brands Hatch on Saturday. David will be amongst over [*sic.*] prominent people who will line up on the starting grid in the personalities race at the John Player Grand Prix. Today, David went to the Brands Hatch circuit for practice and to get the feel of the car. After about ten laps he commented he was happier in an aeroplane.' July 1974.

➤ James Hunt at Brands Hatch, 1974.

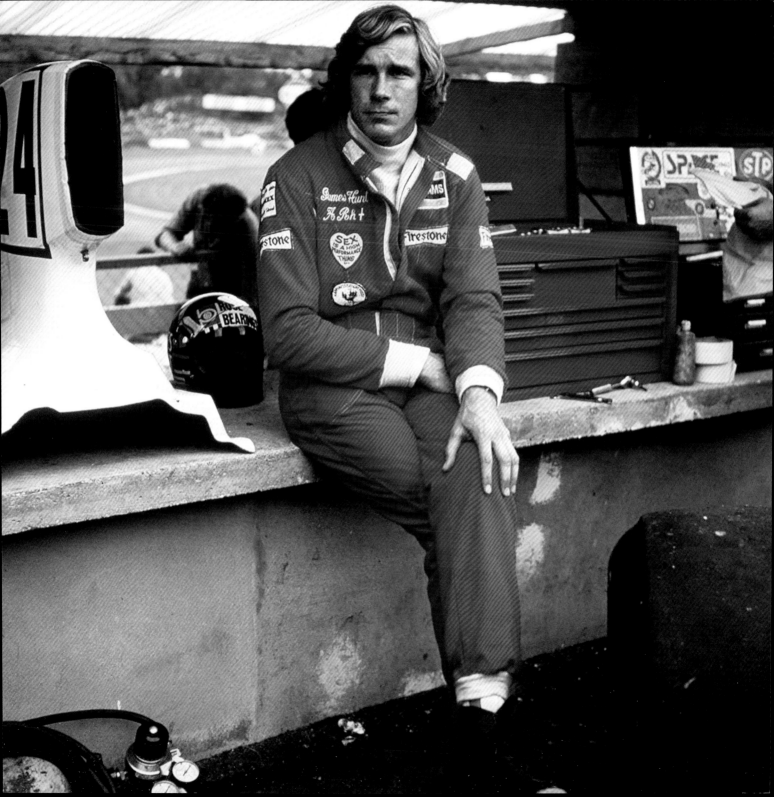

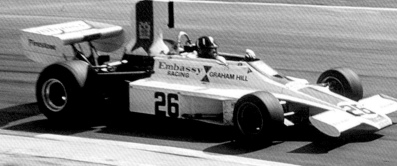

▲ Graham Hill racing at the British Formula One Grand Prix, Brands Hatch, July 1974.

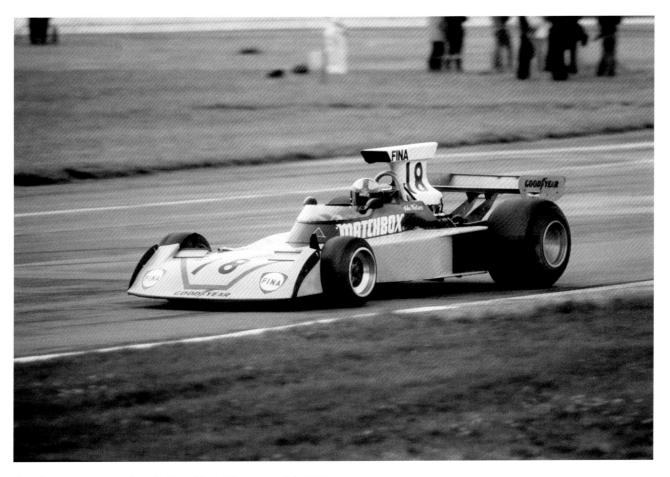

⋀ John Surtees at the British Grand Prix, Silverstone, July 1975.

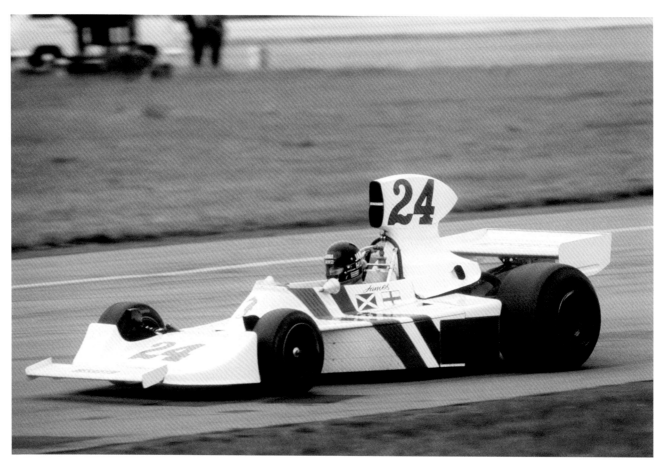

▲ James Hunt at the British Grand Prix, Silverstone, July 1975.

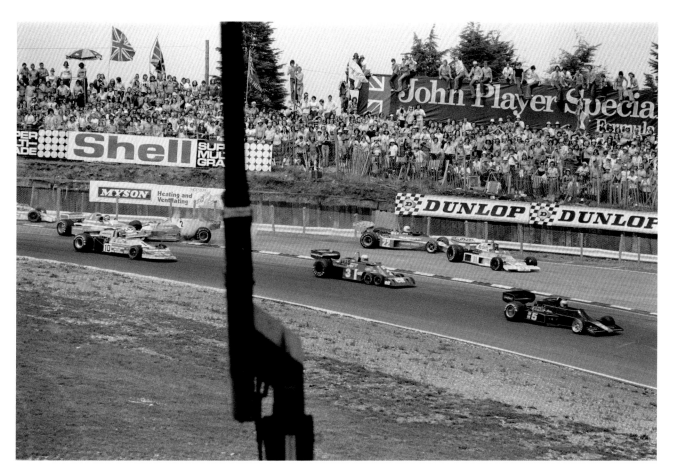

∧ British driver James Hunt (in the Texaco McLaren, second from the right, off track numbered 11) crashes.

James Hunt was involved in a first corner crash that caused a five-car pile-up and brought out the red flags. Hunt drove his damaged car back to the pits, but did not complete a full lap of the track to do so, instead driving through an access road on the Cooper Straight. The officials declared that, since he had not been on the circuit when the red flag was waved, Hunt would not be allowed to take part in the restart. This news led to much angry feeling amongst the British crowd, who chanted Hunt's name until the stewards, fearing crowd trouble, announced that he would be allowed to take the restart. Hunt duly won the restarted race.

Immediately after the race, the Ferrari, Tyrrell and Fittipaldi teams protested against the inclusion of Hunt's car. In September, two months after the event, a decision was reached and Hunt was disqualified, giving Niki Lauda the race win.

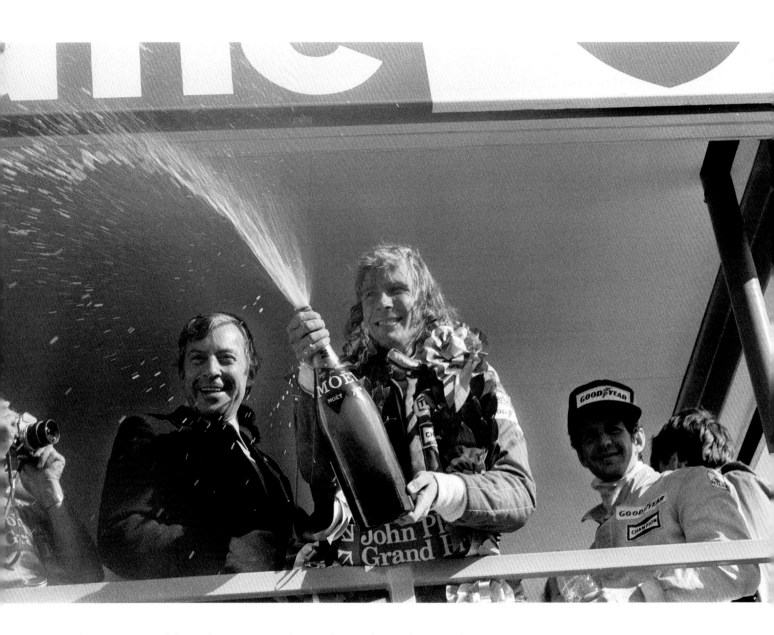

▲ James Hunt celebrates his controversial win at the British Grand Prix, 19 July 1976.

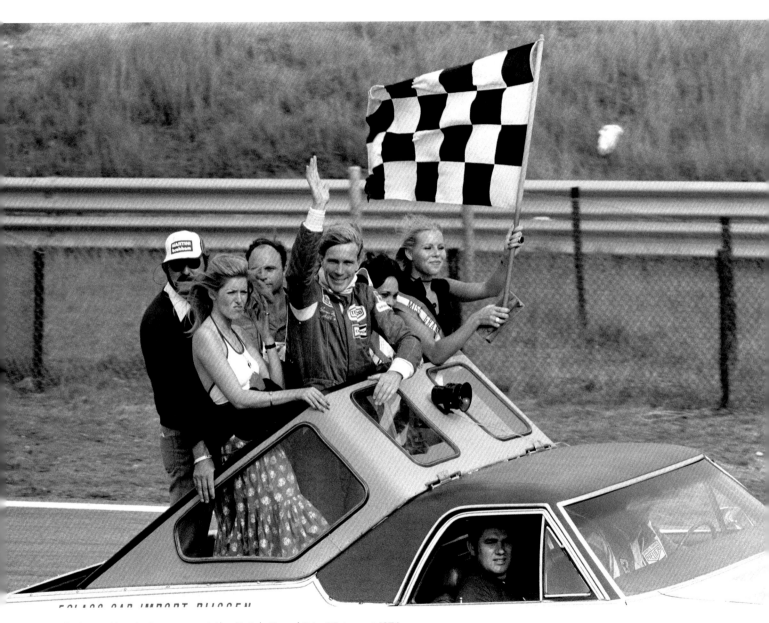

▲ James Hunt's victory run at the Dutch Grand Prix, 29 August 1976.

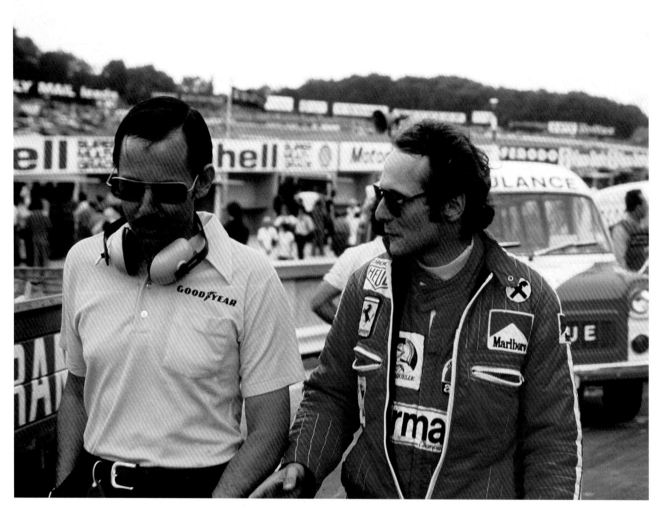

⋏ Niki Lauda for Ferrari in the number 1 car. British Grand Prix, Brands Hatch, July 1976.

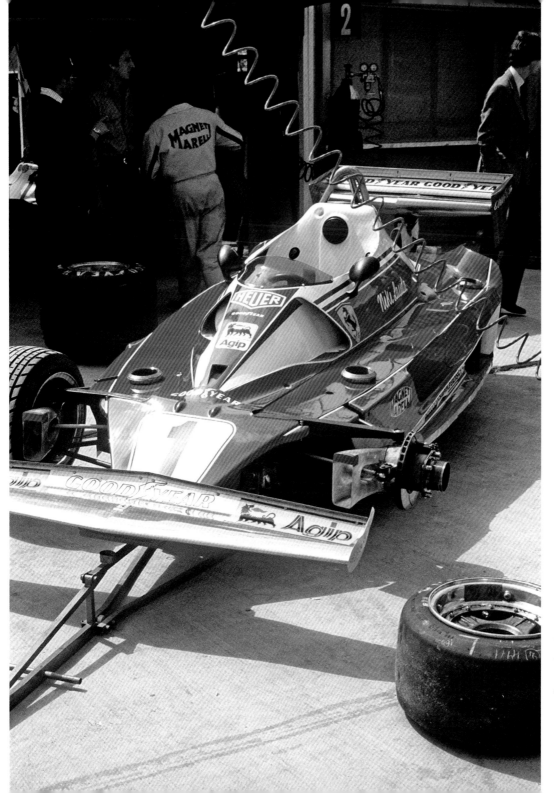

◄ Niki Lauda's Ferrari number 1 car in the Ferrari garage pits at Brands Hatch, July 1976.

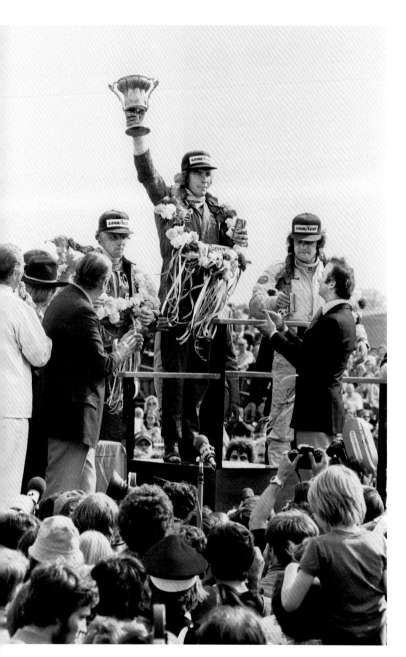

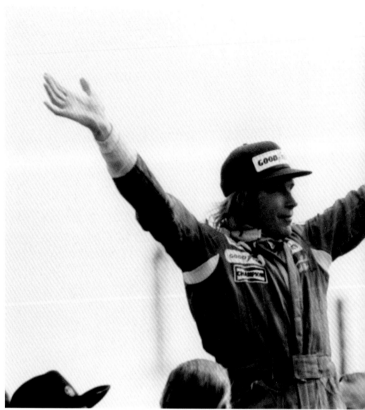

◀⋀ James Hunt celebrates on the podium after winning the British Grand Prix Formula One motor race at Silverstone on 16 July 1977. The race marked the debut of both Canadian driver Gilles Villeneuve and the first turbocharged Formula One car, the Renault RS01, driven by Jean-Pierre Jabouille.

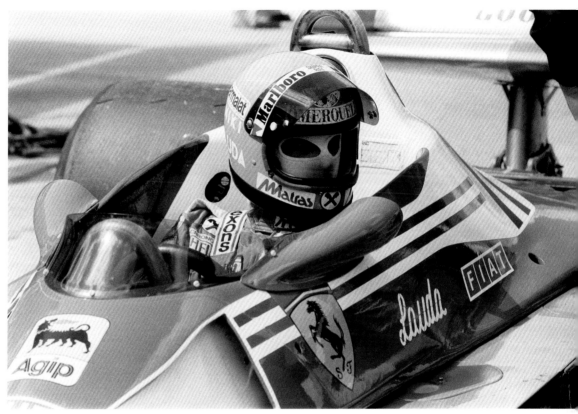

▲ The top racing drivers have their last practice runs at Silverstone; Niki Lauda is in full protective harness, 14 July 1977.

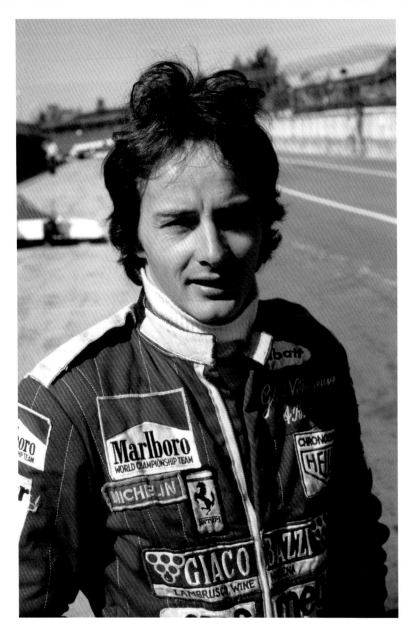

▲ Canadian driver Gilles Villeneuve at Brands Hatch, 1980.

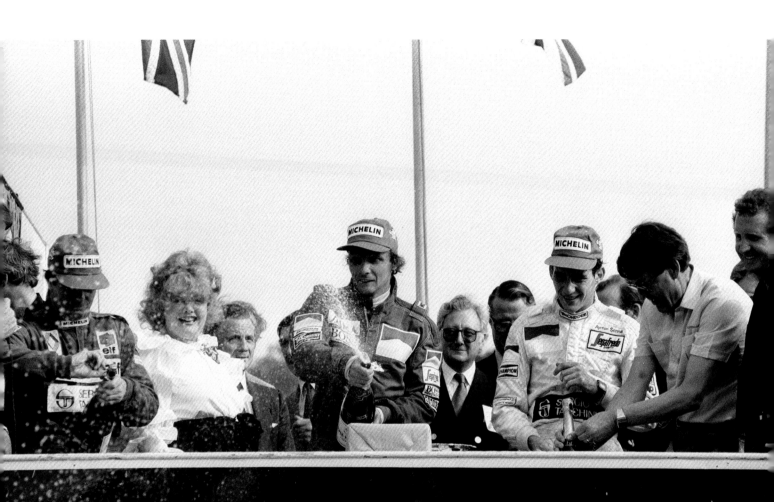

▲ Race winner Niki Lauda (centre) with Derek Warwick (second place, left) and Ayrton Senna (third place, right) at the British Grand Prix, Brands Hatch, 22 July 1984.

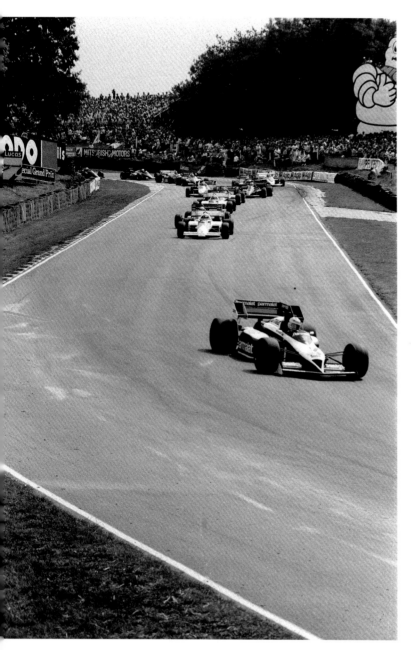

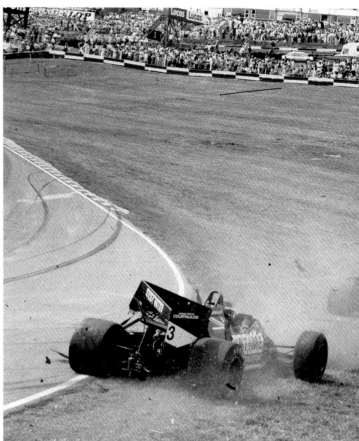

►▲ An accident involving Jo Gartner and Philippe Alliot. British Grand Prix, Brands Hatch, 22 July 1984.

◄ British Grand Prix, Brands Hatch, 22 July 1984.

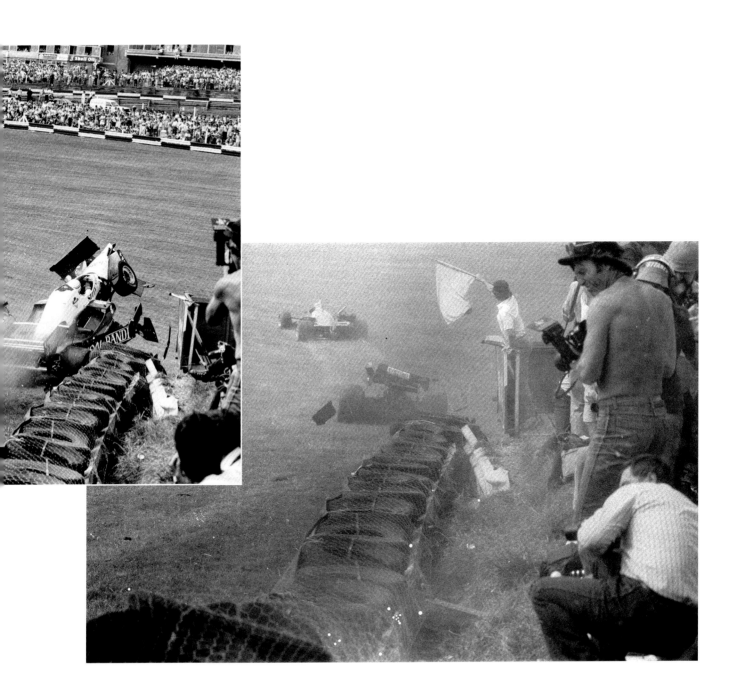

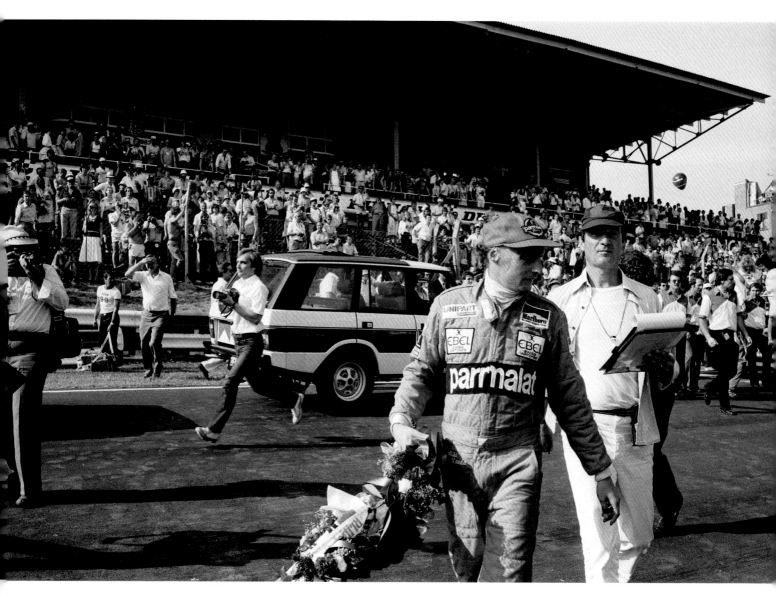

▲ Niki Lauda, driving a Marlboro-McLaren, wins the British Grand Prix at Brands Hatch on 18 July 1982. This win moved Lauda, world champion in 1975 and 1977, to third place in the Drivers' Championship, behind Didier Pironi and John Watson.

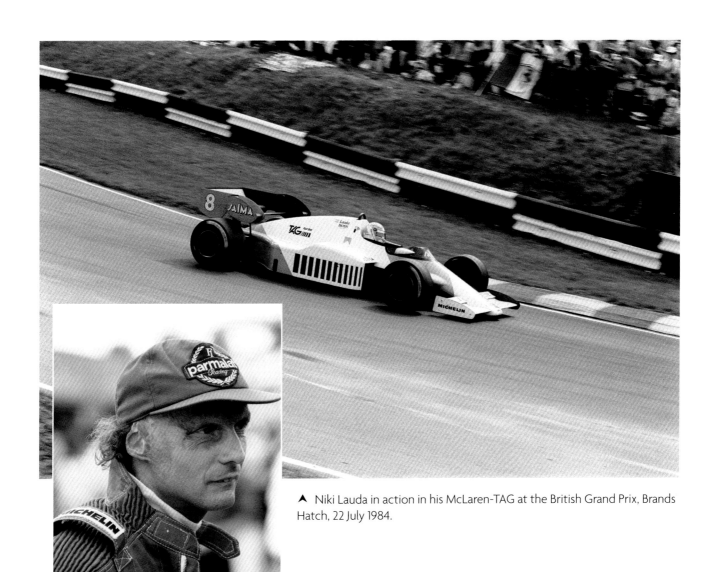

⋏ Niki Lauda in action in his McLaren-TAG at the British Grand Prix, Brands Hatch, 22 July 1984.

◄ Race winner Niki Lauda. British Grand Prix, Brands Hatch, 22 July 1984.

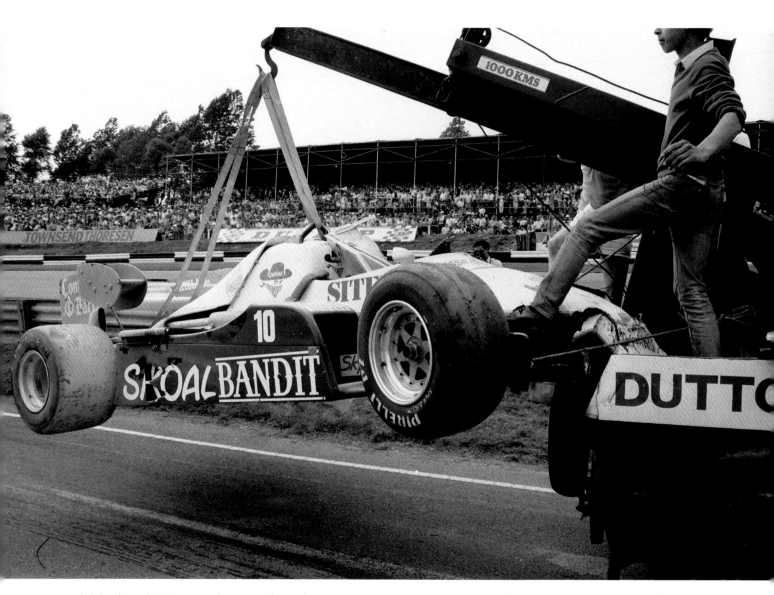

▲ Skoal Bandit RAM-Hart driver Jonathan Palmer's car is taken away from the track after an accident. British Grand Prix, Brands Hatch, 22 July 1984.

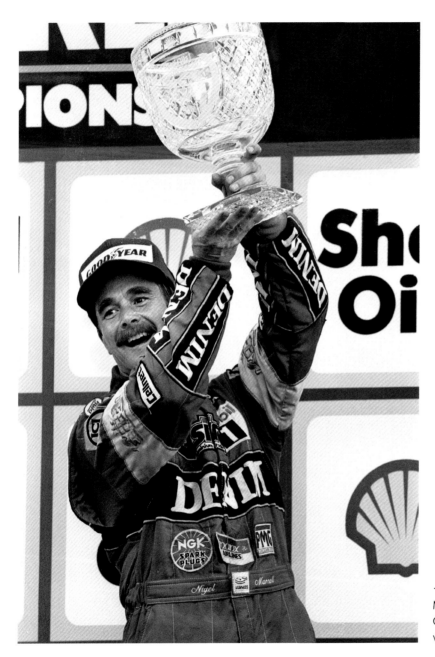

◄ Williams Formula One driver Nigel Mansell was the last winner of a British Grand Prix at Brands Hatch; later races would be held at Silverstone. 10 July 1986.

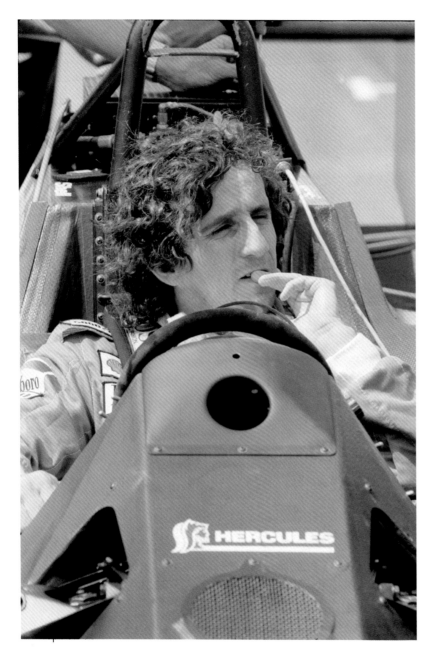

◄▲ Alain Prost at Silverstone, June 1986

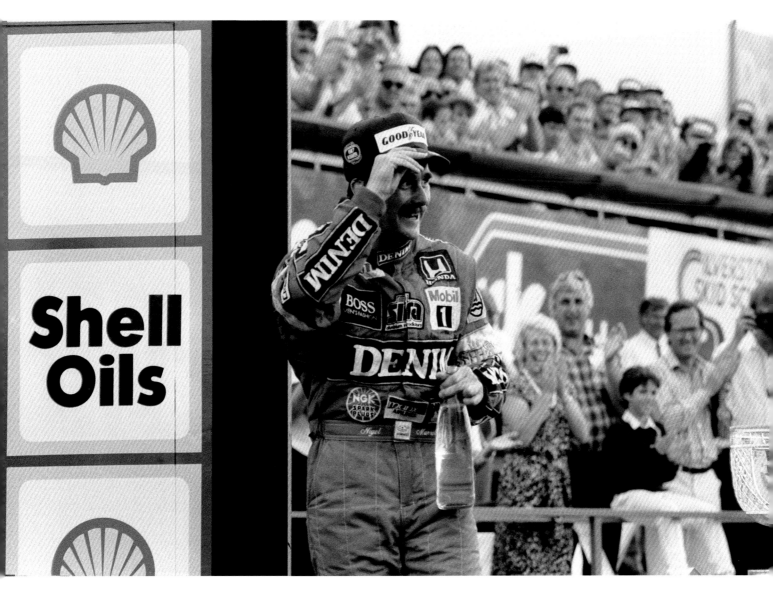

▲ Williams driver Nigel Mansell is seen here celebrating on the podium after beating his teammate Nelson Piquet in dramatic fashion to win at Silverstone, 12 July 1987.

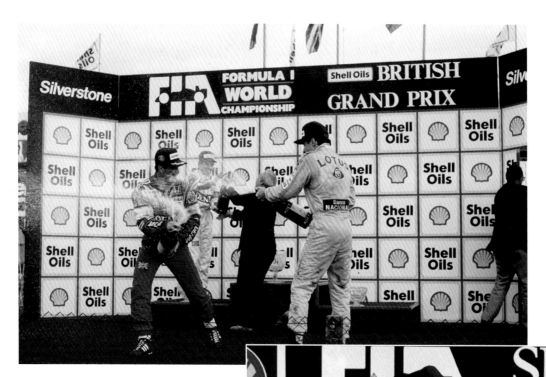

∧ A rainy race for Nigel Mansell, Nelson Piquet and Ayrton Senna at Silverstone, 1988

➤ Nigel Mansell (second place, left) and Alain Prost (first place, right) on the winners' podium at Silverstone, 1989.

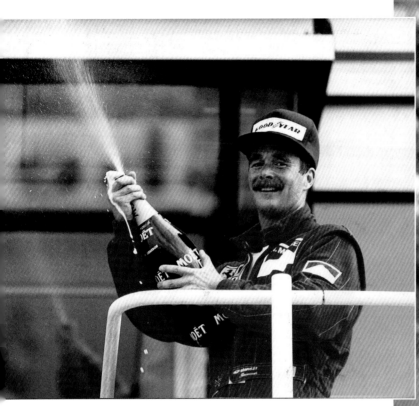

▲ Nigel Mansell celebrating his 1989 second place.

➤ Ayrton Senna, Silverstone, 1989.

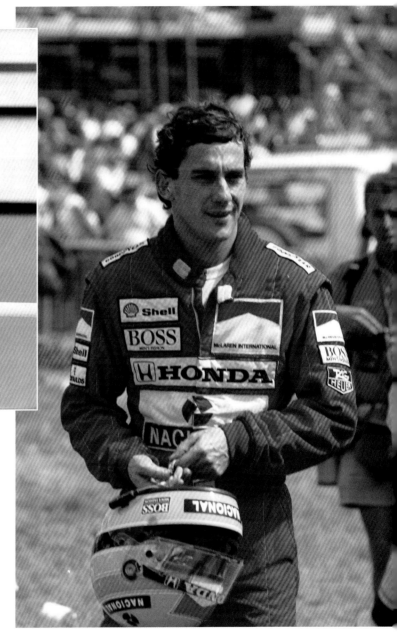

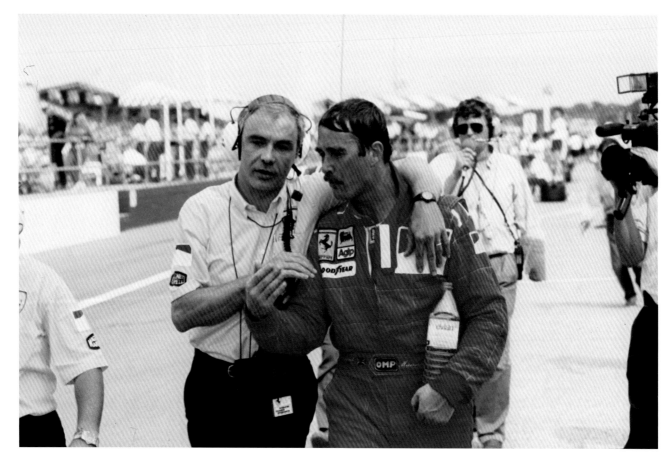

▲ Nigel Mansell walks from the track after a gearbox malfunction forced him to abandon the race. Mansell announced his retirement from F1 after the race, but later changed his mind. British Grand Prix, Silverstone, 15 July 1990.

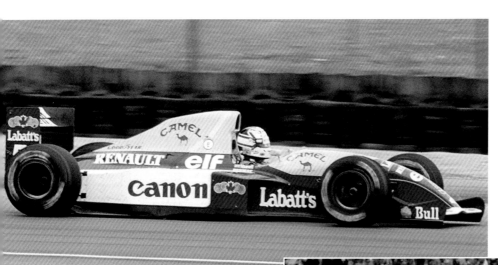

▲ Nigel Mansell dominates on Silverstone's new circuit for William-Renault, May 1991.

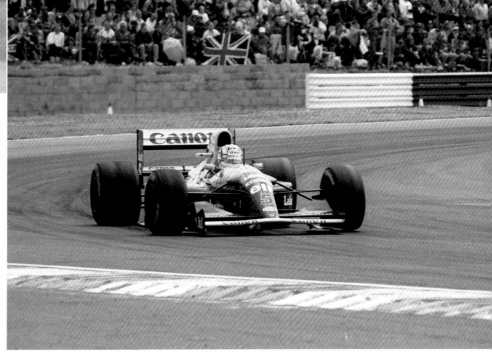

➤ Nigel Mansell winning the British Grand Prix, July 1992

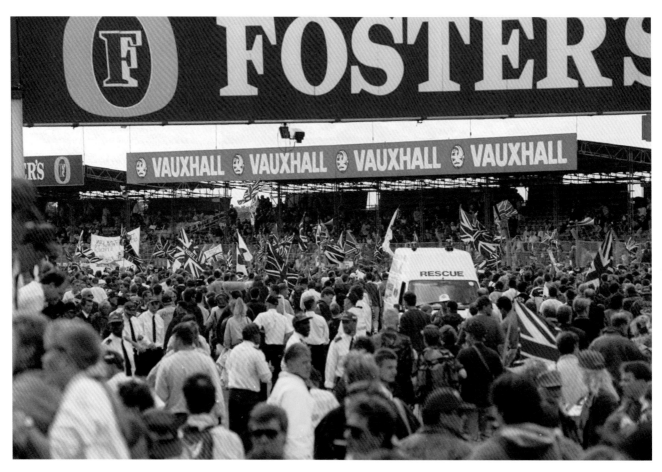

▲ A large crowd celebrating after Nigel Mansell wins the British Grand Prix, July 1992.

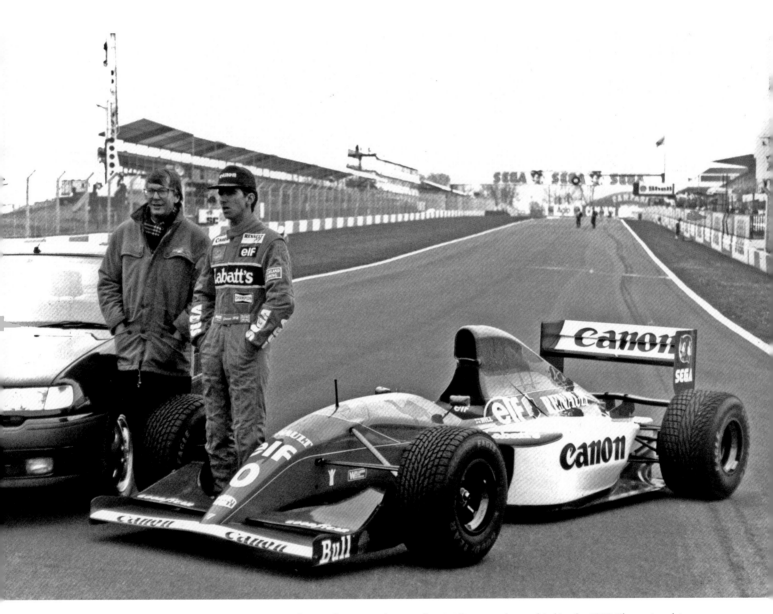

▲ Damon Hill, later World Champion 1996, took over from Nigel Mansell at Williams and was third in the 1993 Championship at the time of this photo.

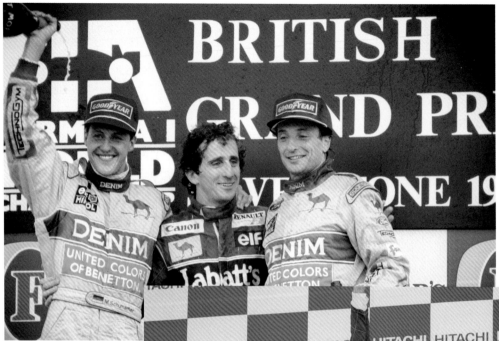

◄ 1993 British Grand Prix at Silverstone. Winner Alain Prost of Williams-Renault (centre) with Benneton-Ford drivers Michael Schumacher (second place, left) and Riccardo Patrese (third place, left), 11 July 1993.

➤ On the podium is Damon Hill, who won the race for Williams-Renault, with Michael Schumacher of Benetton-Ford (second place, left) looking far from happy, and Gerhard Berger of Ferrari (third place). The prizes were presented by Princess Diana at Silverstone, 10 July 1994.

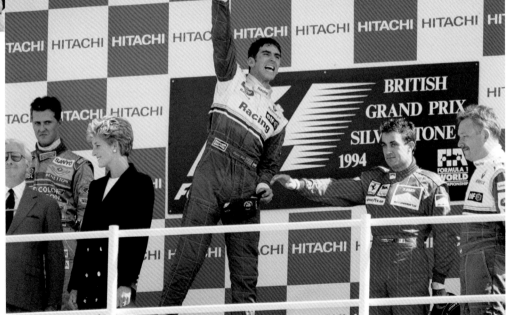

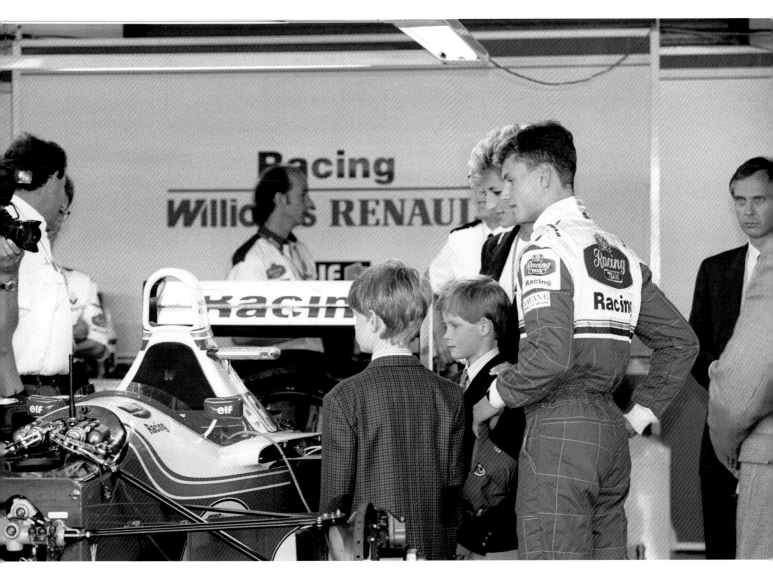

▲ Princess Diana attends the 1994 British Grand Prix with youngest son Prince Harry, aged 9 years old. David Coulthard shows his royal guests around the Williams-Renault garage in the pits. Silverstone, 1994.

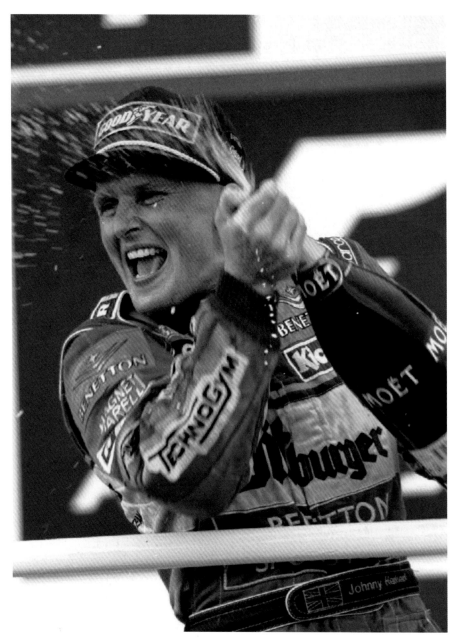

◄ Johnny Herbert celebrates after winning the Grand Prix at Silverstone, 16 July 1995.

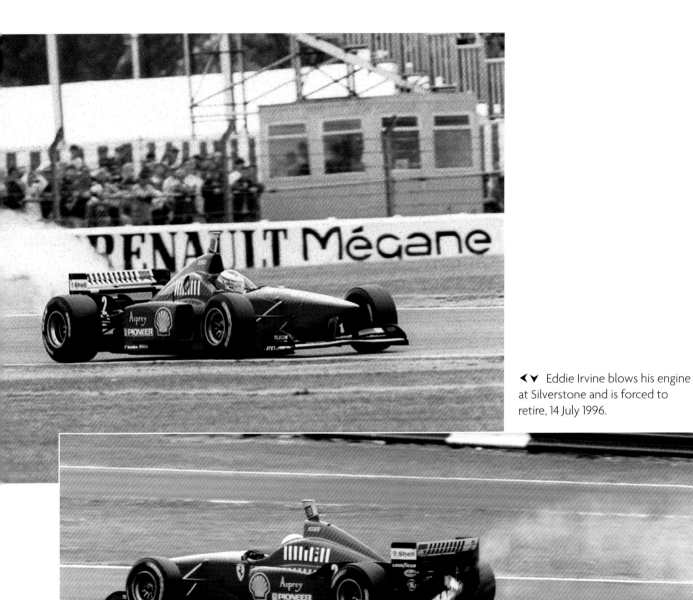

◀▾ Eddie Irvine blows his engine at Silverstone and is forced to retire, 14 July 1996.

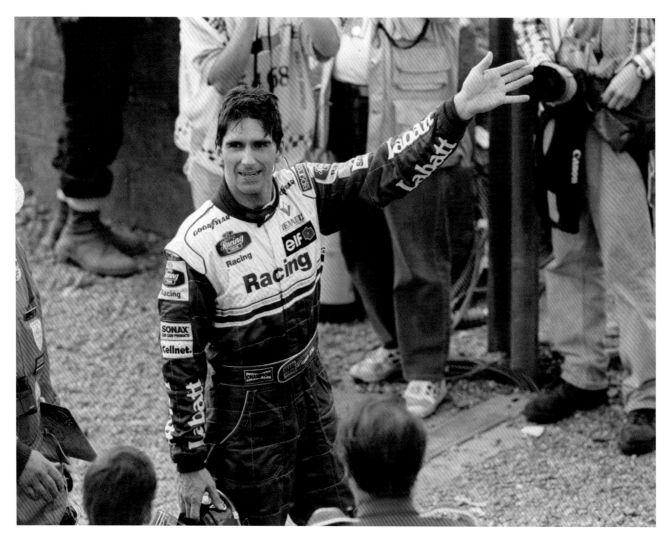

▲ Damon Hill, driver for Williams-Renault, after spinning off on lap 27 during the British Grand Prix at Silverstone, which was Round 10 of the 1996 Formula One Championship 1996. The race would be won by his teammate Canadian Jacques Villeneuve.

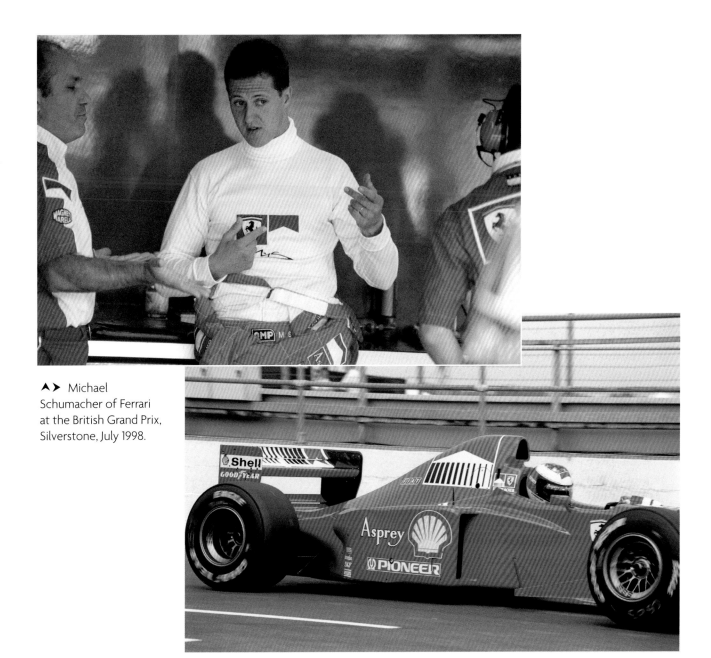

▲➤ Michael
Schumacher of Ferrari
at the British Grand Prix,
Silverstone, July 1998.

➤ Damon Hill at the British Grand Prix Silverstone Qualifying Session, 11 July 1998.

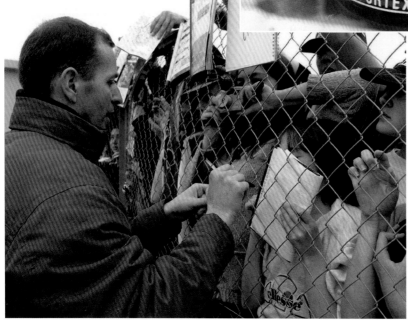

◀ Formula One driver-turned-commentator Martin Brundle stops to sign autographs. Silverstone, 11 July 1998.

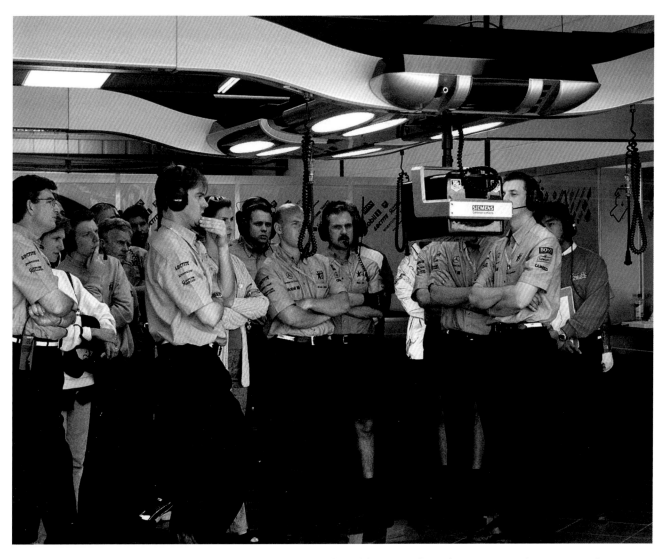

▲ The McLaren pit crew watch the fastest qualifying driver Mika Häkkinen get the pole position at Silverstone, 11 July 1998.

▲ Frank Williams, founder of the Williams team, at Silverstone, 11 July 1998.

➤ Eddie Irvine at Silverstone, 11 July 1998.

▲ Eddie Jordan, team manager, watches Damon Hill during the warm-up session at Silverstone, 1999

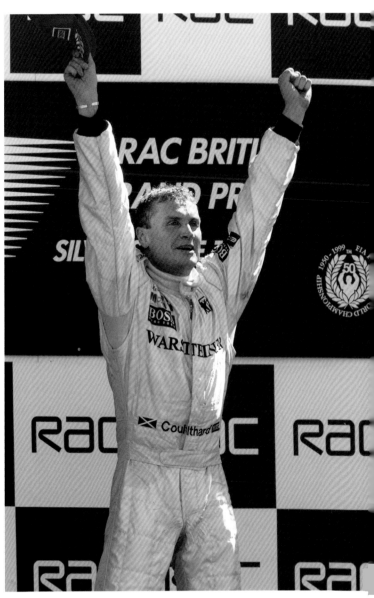

▲ David Coulthard wins at Silverstone, 11 July 1999.

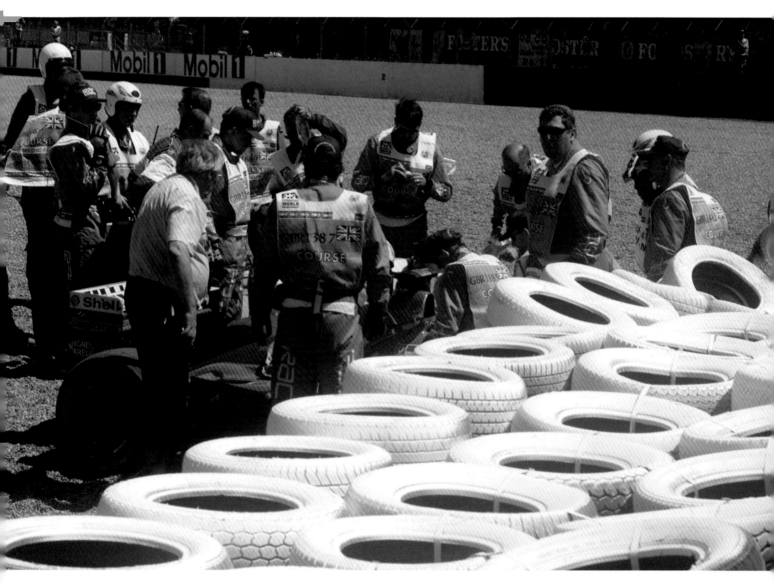

▲ Stewards try to help Michael Schumacher out of his Ferrari after he crashed into the wall of tyres and broke his leg, 11 July 1999.

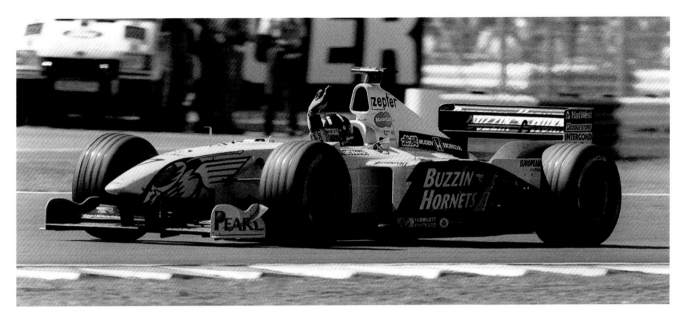

▲ Damon Hill waves to the crowd at the end of the race, 11 July 1999.

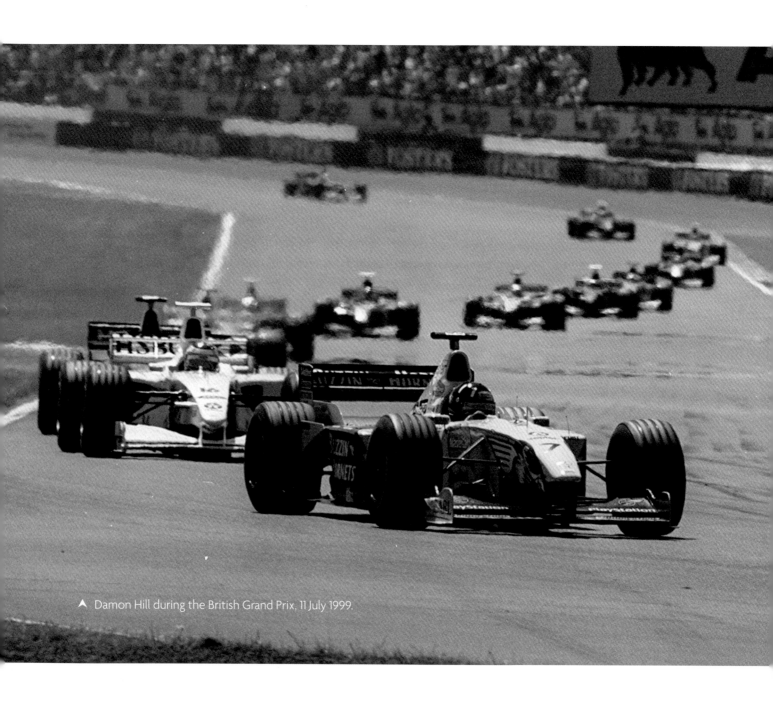

▲ Damon Hill during the British Grand Prix, 11 July 1999.

▲ Eddie Irvine gets some personal attention in the pits, 11 July 1999.

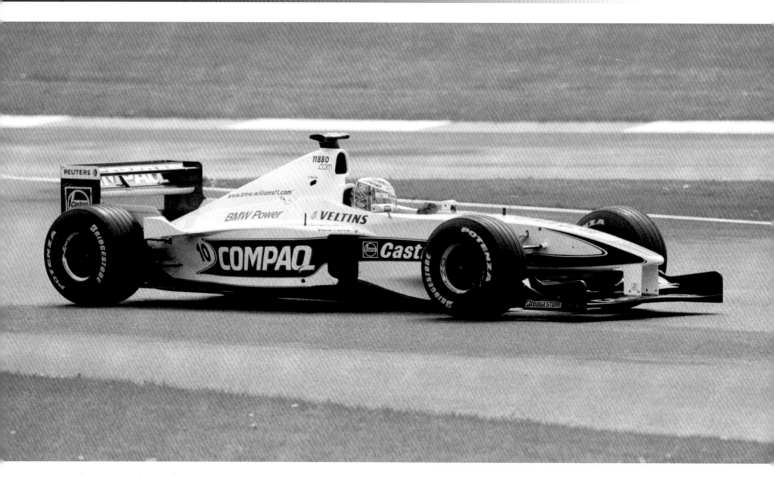

▲ BMW Williams driver Jenson Button driving at Silverstone in the 2000 British Grand Prix.

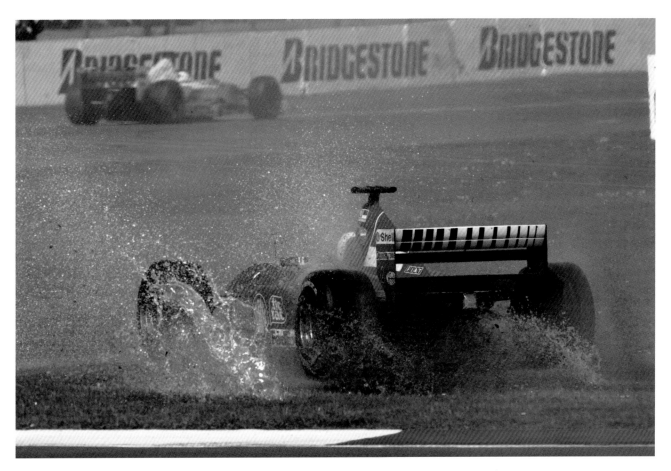

▲ Rubens Barrichello of Ferrari in action during the British Grand Prix, April 2000.

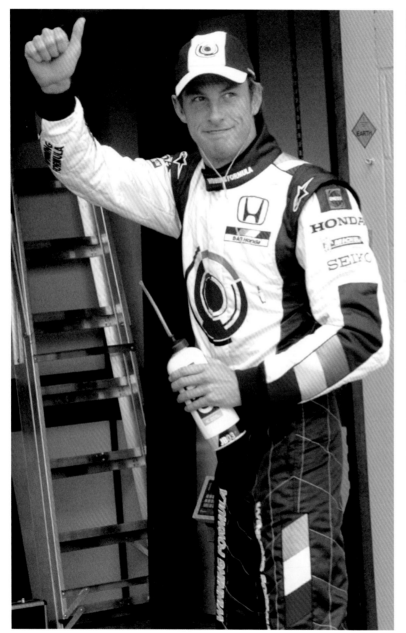

◄ Jenson Button celebrates his second place on the grid, April 2000.

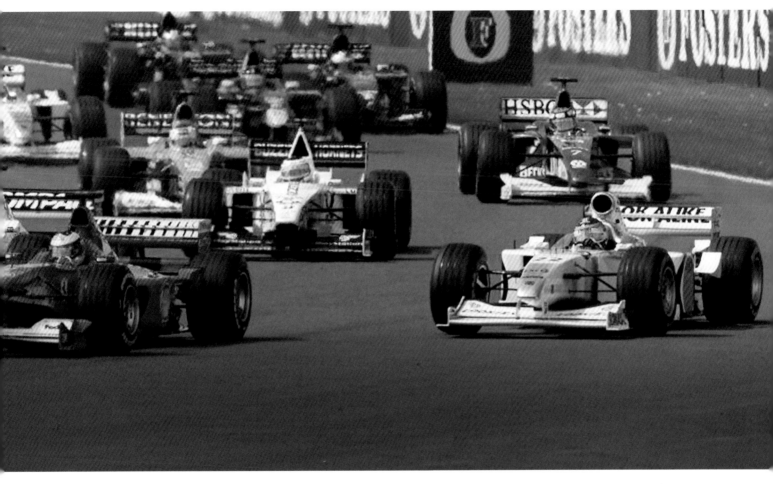

▲ Jenson Button's Williams car alongside Michael Schumacher's Ferrari at the first corner of the British Grand Prix, April 2000.

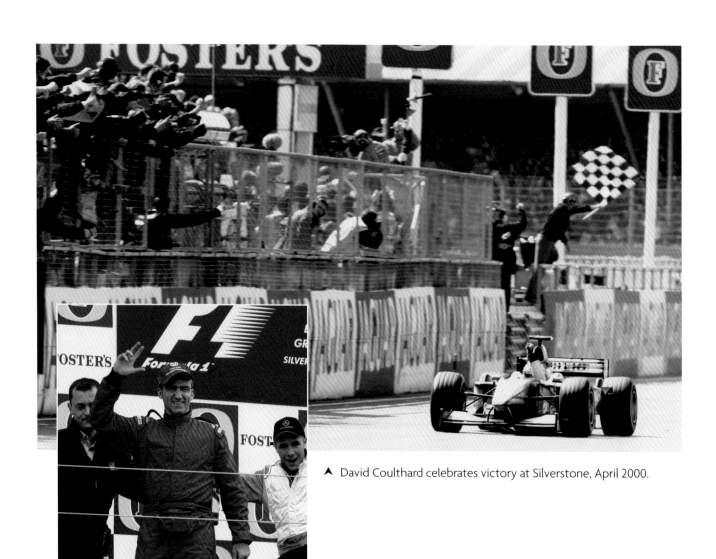

▲ David Coulthard celebrates victory at Silverstone, April 2000.

◄ The podium at the 2002 British Grand Prix is hijacked by prankster Karl Power and friends, who did an Irish jig before they were ushered off by security to make way for Michael Schumacher, the actual winner.

◄ Michael Schumacher at Silverstone, July 2002.

❯ Michael Schumacher takes the chequered flag in front of Ferrari fans waving their flags, Silverstone, July 2002.

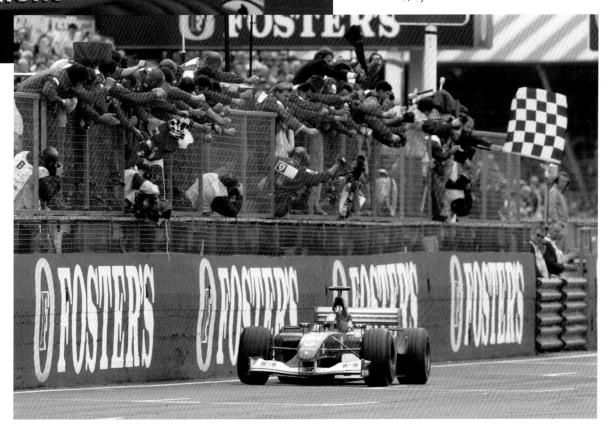

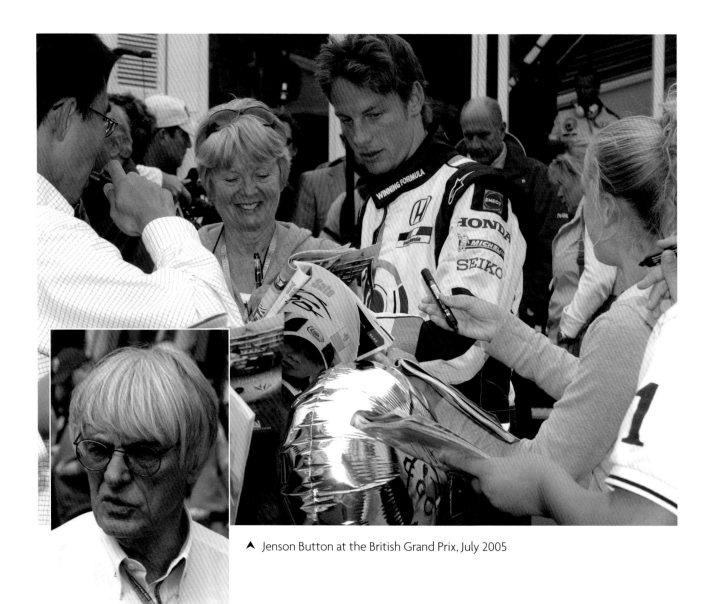

▲ Jenson Button at the British Grand Prix, July 2005

◄ Bernie Ecclestone at the British Grand Prix, July 2005. The 2005 race nearly didn't happen due to crippling fees demanded by Ecclestone, but an agreement was reached at the eleventh hour.

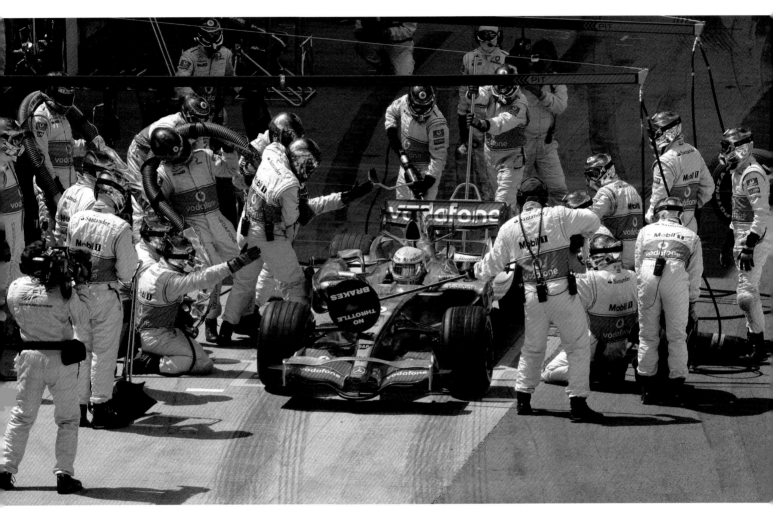

▲ Lewis Hamilton pulls in at the pit stop, a move that would cost him the race at Silverstone, 8 July 2007.

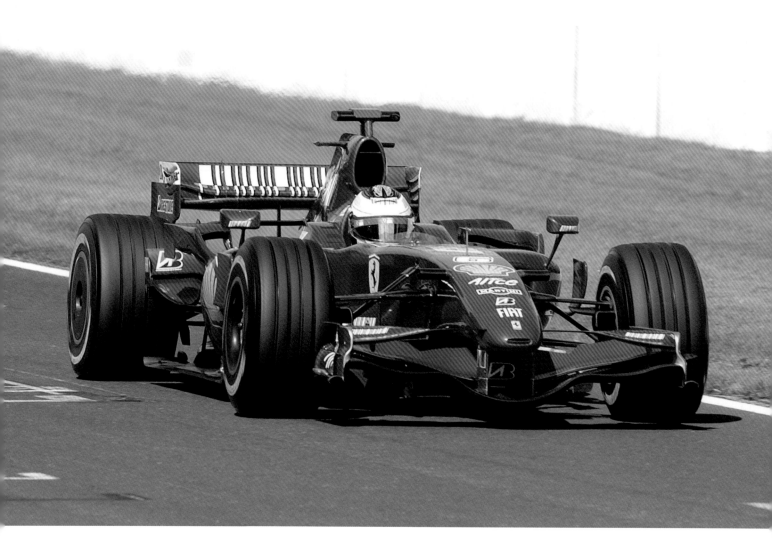

▲ Ferrari driver Kimi Räikkönen, the 2007 race winner, testing at Silverstone.

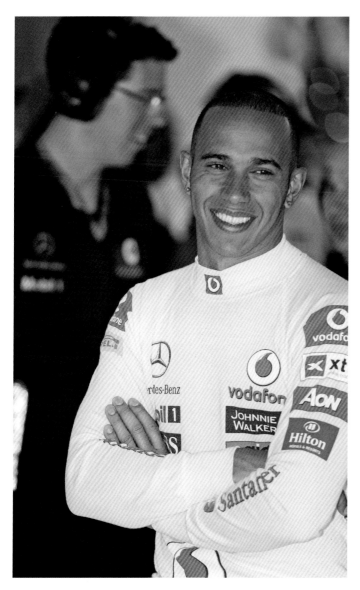

∧ Lewis Hamilton during afternoon practice, 5 July 2008.

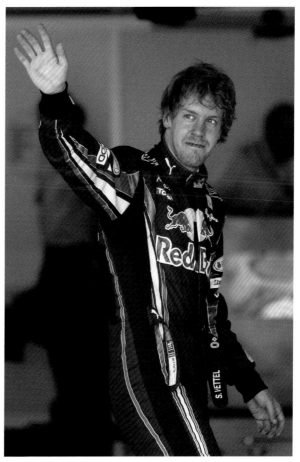

∧ Sebastian Vettel was the winner of the 2009 Grand Prix, which was scheduled to be the last at Silverstone in favour of moving to Donnington Park from 2010. This move was cancelled when the required funds could not be raised and a seventeen-year contract was then signed for Silverstone. This contract was due to end in 2019, but was extended until 2024.

Here, Vettel celebrates after taking pole position at Silverstone, 10 July 2010.

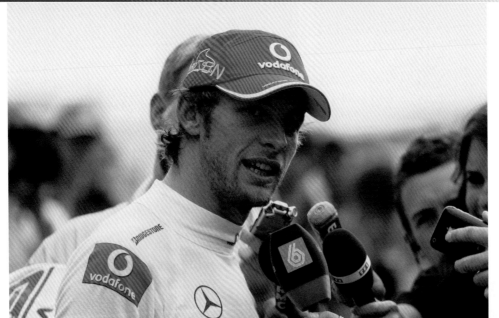

◄ Vodafone McLaren Mercedes driver Jenson Button gives press interviews after his disappointing fourteenth place grid position for the race, 10 July 2010.

➤ Red Bull's Mark Webber celebrates his win on the podium with his trophy and champagne, 11 July 2010.

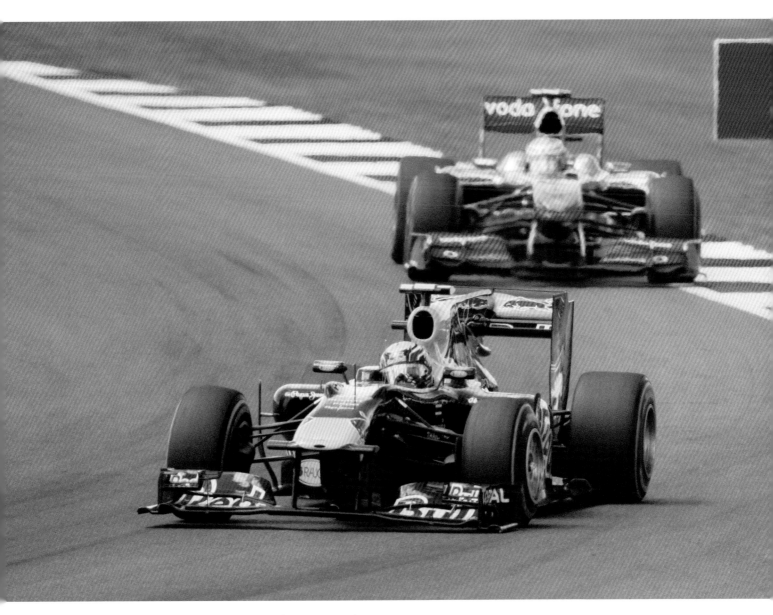

▲ Mark Webber leads Lewis Hamilton at Silverstone, 11 July 2010.

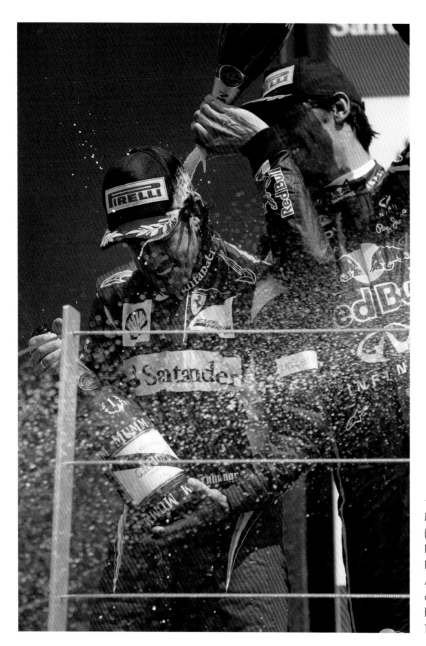

◄ Red Bull's
Mark Webber
(right) helps
Ferrari's
Fernando
Alonso
celebrate
his race win,
11 July 2010.

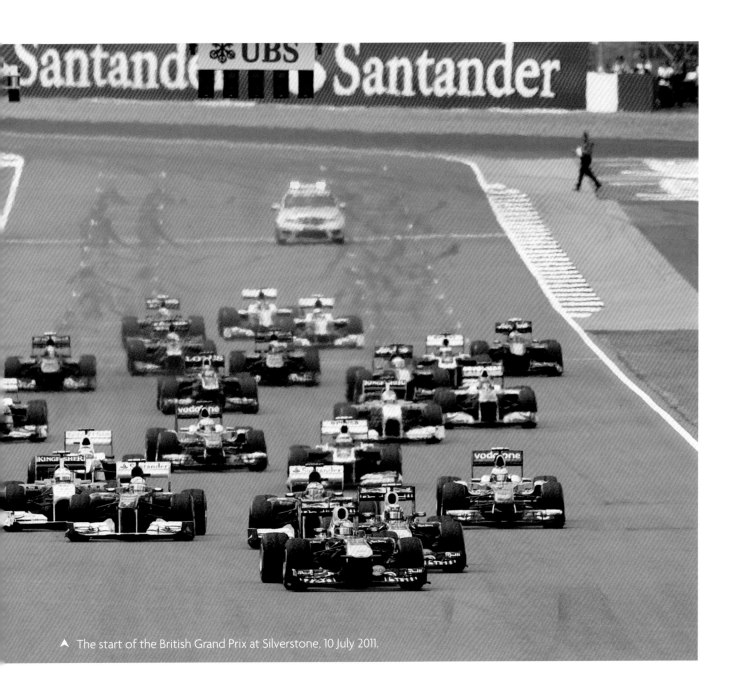
▲ The start of the British Grand Prix at Silverstone, 10 July 2011.

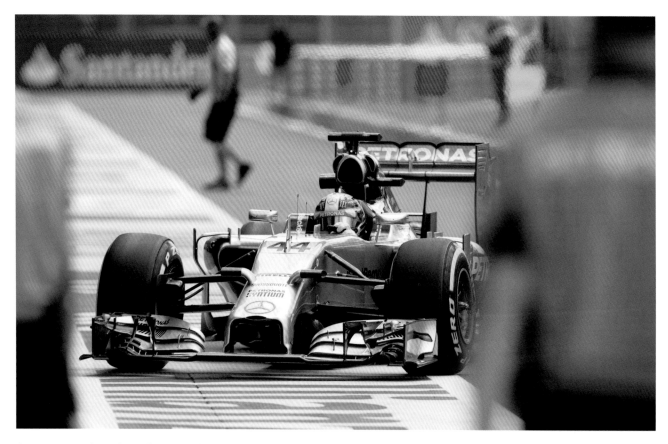

▲ Lewis Hamilton during his second practice session, 2014.

➤ Lewis Hamilton wins the British Grand Prix at Silverstone, 6 July 2014.

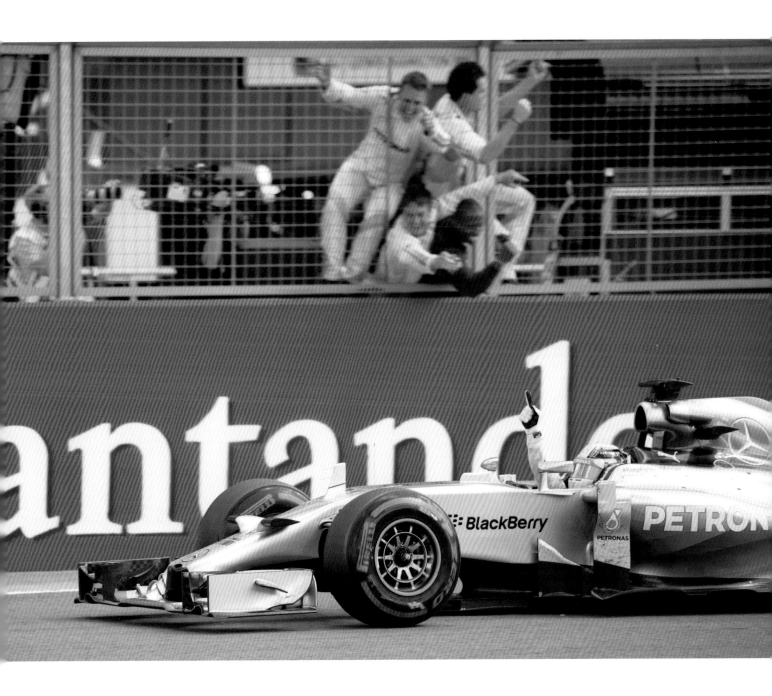

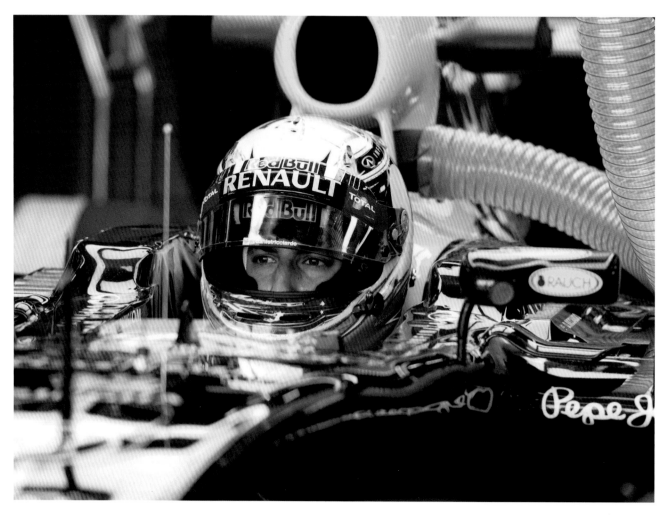

⋀ Daniel Ricciardo during his second practice session at Silverstone, 4 July 2014.

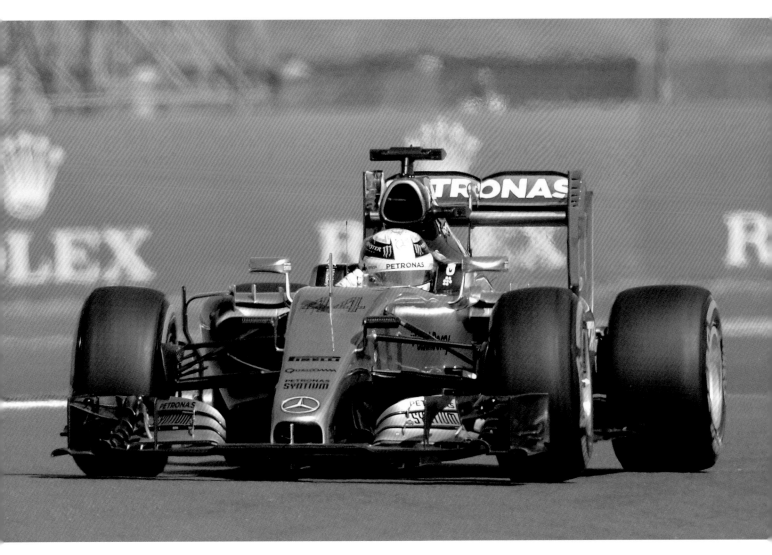

▲ Lewis Hamilton at Silverstone, 3 July 2015.

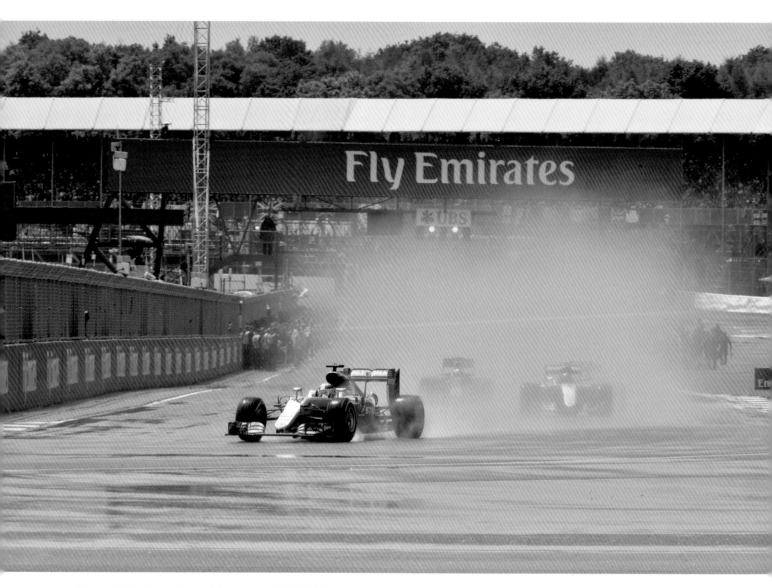

⋏ Lewis Hamilton wins at Silverstone, 10 July 2016.

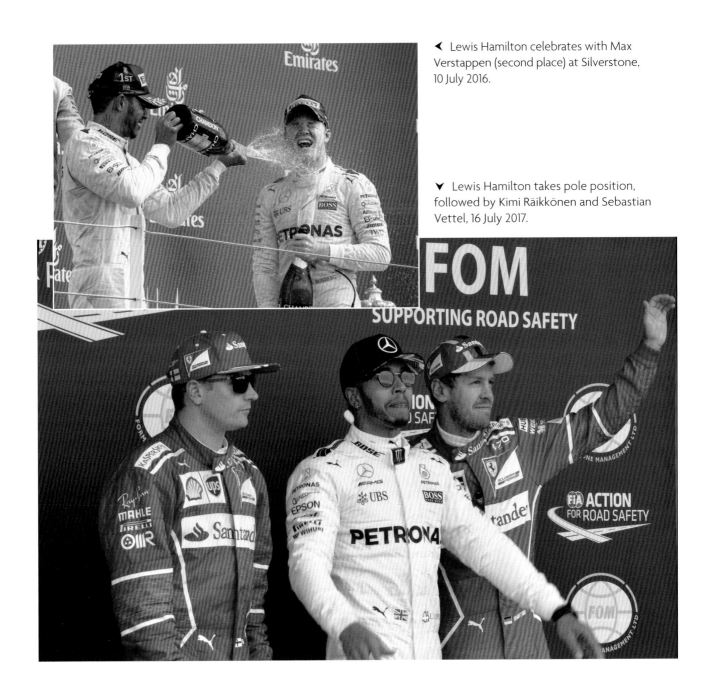

◄ Lewis Hamilton celebrates with Max Verstappen (second place) at Silverstone, 10 July 2016.

▼ Lewis Hamilton takes pole position, followed by Kimi Räikkönen and Sebastian Vettel, 16 July 2017.

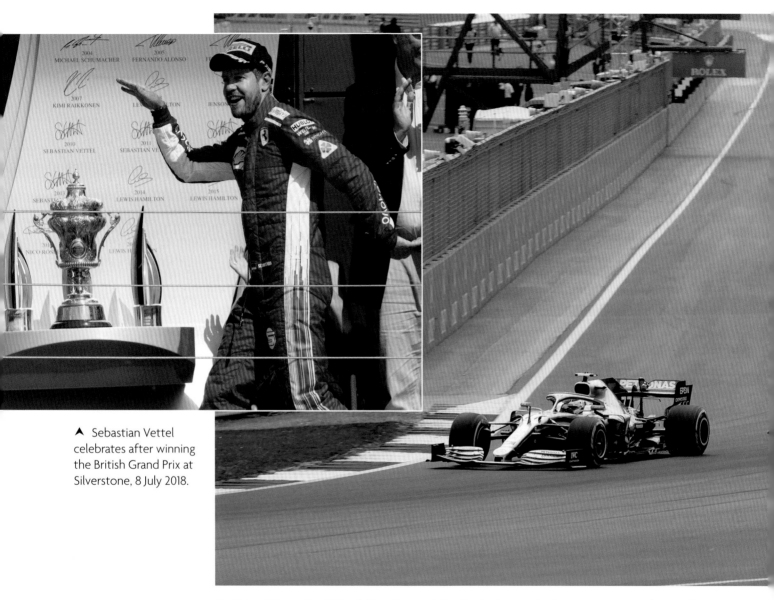

▲ Sebastian Vettel
celebrates after winning
the British Grand Prix at
Silverstone, 8 July 2018.

▲ Valtteri Bottas leads Lewis Hamilton and Charles Leclerc at the first corner during the British
Grand Prix, 14 July 2019.

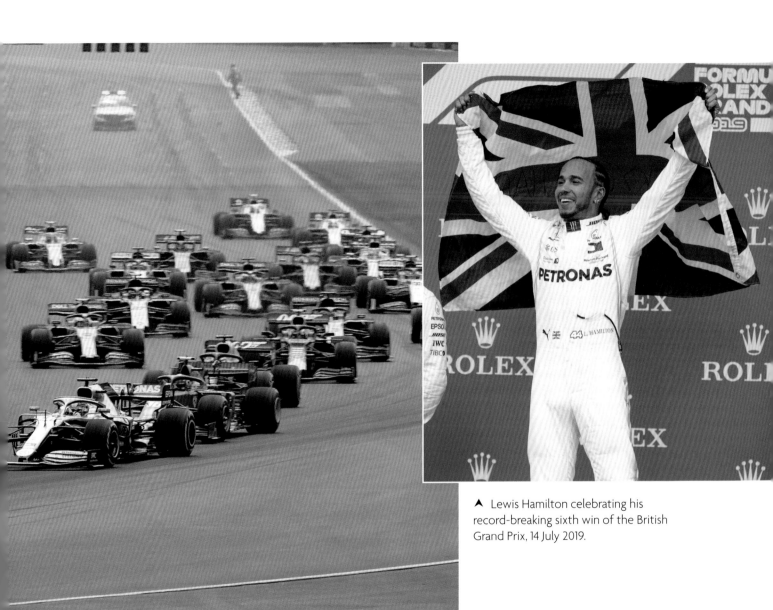

▲ Lewis Hamilton celebrating his record-breaking sixth win of the British Grand Prix, 14 July 2019.

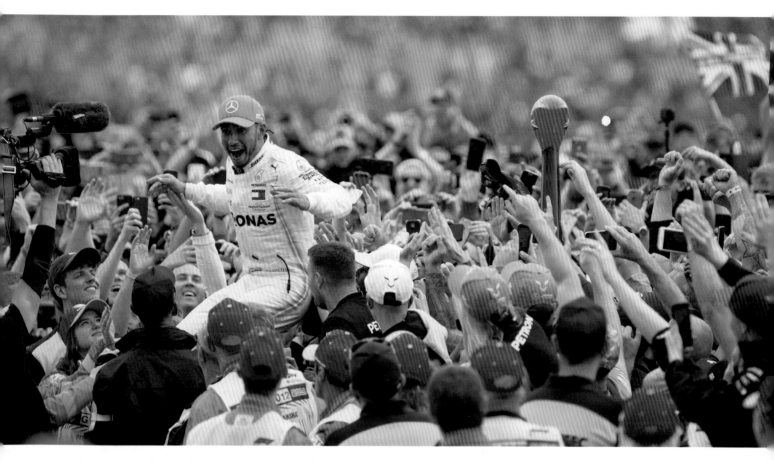

▲ Lewis Hamilton and fans at Silverstone, 14 July 2019.